P9-DNS-675

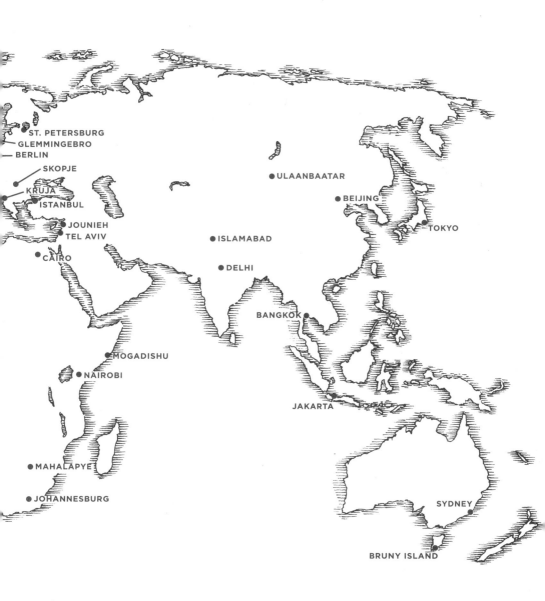

ST. PETERSBURG
GLEMMINGEBRO
BERLIN
SKOPJE
KRUJA
ISTANBUL
JOUNIEH
TEL AVIV
CAIRO
ULAANBAATAR
BEIJING
TOKYO
ISLAMABAD
DELHI
BANGKOK
MOGADISHU
NAIROBI
JAKARTA
MAHALAPYE
JOHANNESBURG
SYDNEY
BRUNY ISLAND

JAN - - 2015

ALSO BY MATTEO PERICOLI

LONDON UNFURLED

LONDON FOR CHILDREN

THE CITY OUT MY WINDOW

MANHATTAN UNFURLED

MANHATTAN WITHIN

WORLD UNFURLED

SEE THE CITY

THE TRUE STORY OF STELLINA

TOMMASO AND THE MISSING LINE

WINDOWS ON THE WORLD

FIFTY WRITERS, FIFTY VIEWS

MATTEO PERICOLI

with a preface by Lorin Stein

PENGUIN PRESS

NEW YORK

2014

WILLIAMSBURG REGIONAL LIBRARY
7770 CROAKER ROAD
WILLIAMSBURG, VA 23188

PENGUIN PRESS
Published by the Penguin Group
Penguin Group (USA) LLC
375 Hudson Street
New York, New York 10014

USA · Canada · UK · Ireland · Australia
New Zealand · India · South Africa · China

penguin.com
A Penguin Random House Company

First published by Penguin Press, a member of Penguin Group (USA) LLC, 2014

Copyright © 2014 by Matteo Pericoli
Preface copyright © 2014 by Lorin Stein
Penguin supports copyright. Copyright fuels creativity, encourages diverse voices,
promotes free speech, and creates a vibrant culture. Thank you for buying an authorized edition of this book and for
complying with copyright laws by not reproducing, scanning, or distributing any part of it in any form without
permission. You are supporting writers and allowing Penguin to continue to publish books for every reader.

The selections with texts by the following writers appeared in *The New York Times*:
Chimamanda Ngozi Adichie, Alaa Al Aswany, Rana Dasgupta, Marina Endicott, Nuruddin Farah,
Richard Flanagan, Nadine Gordimer, Daniel Kehlmann, Maria Kodama, Elmore Leonard, Andrea Levy,
Ryu Murakami, and Orhan Pamuk.
The selections with texts by the following writers appeared in *The Paris Review*: Nastya Denisova,
Lidija Dimkovska, Francisco Goldman, Sheila Heti, Andrea Hirata, Etgar Keret, Harris Khalique,
Emma Larkin, Luljeta Lleshanaku, Andri Snær Magnason, Mike McCormack, G. Mend-Ooyo,
Tim Parks, Tatiana Salem Levy, Taiye Selasi, John Jeremiah Sullivan, Lysley Tenorio,
Binyavanga Wainaina, Rebecca Walker, Xi Chuan, and Alejandro Zambra.

Front and back endpaper maps by Matteo Pericoli

LIBRARY OF CONGRESS CATALOGING-IN-PUBLICATION DATA

Windows on the world : fifty writers, fifty views / Matteo Pericoli ; preface by Lorin Stein.
pages cm
ISBN 978-1-59420-554-5 (hardback)
1. Windows—Literary collections. 2. Authorship.
3. Windows in literature. 4. Authors—Biography.
I. Pericoli, Matteo, 1968–
PN6071.W56W56 2014
808.88'7—dc23 2014032946
Printed in the United States of America

BOOK DESIGN BY CLAIRE NAYLON VACCARO

FOR NADIA

PREFACE

LORIN STEIN

Can you picture John Kennedy Toole, the author of *A Confederacy of Dunces*? I can't. Say his name and I see his hero, Ignatius Reilly. How about Willa Cather? What comes to mind isn't a person at all— it's raindrops in New Mexico "exploding with a splash, as if they were hollow and full of air." What did Barbara Pym look like, or Rex Stout, or Boris Pasternak, or the other writers whose paperbacks filled our parents' bedside tables? In most cases we have no idea, because until recently, the author photo was relatively rare. You could sell a million copies and still, to those million readers, you'd be a name without a face.

Things are different now. Nearly every first novel comes with a glamour shot, not to mention a publicity campaign on Facebook. The very tweeters have their selfies. We still talk about a writer's "vision," but in practice we have turned the lens around, and turned the seer into something seen.

Matteo Pericoli's drawings recall us, in the homeliest, most literal way, to the writer's true business, and the reader's. Each window represents a point of view and a point of origin. Here's what the writer sees when he or she looks up from the computer; here's the native landscape of the writing. If you want an image that will link the creation to its source, Pericoli suggests, this is the image

you should reach for. Not the face, but the vision—or as close as we can come. To look out another person's window, from his or her workspace, may tell us nothing about the work, and yet the space—in its particularity, its foreignness, its intimacy—is an irresistible metaphor for the creative mind; the view, a metaphor for the eye.

It is crucial that these window views should be rendered in pen and ink, in lines, rather than in photographs (even though Pericoli works from snapshots, dozens per window). In his own writing and teaching, Pericoli likes to stress the kinship between draftsman and writer, starting with the importance of the line. His own line is descriptive, meticulous, suspenseful—one slip of the pen and hours of labor could be lost, or else the "mistake" becomes part of the drawing. Labor, it seems to me, is one of Pericoli's hidden subjects. That is part of the meaning of the hundreds of leaves on a tree, or the windows of a high-rise: They record the work it took to see them, and this work stands as a sort of visual correlative, or illustration, of the work his writers do.

Of course, most writers tune out the view from day to day. In the words of Etgar Keret, "When I write, what I see around me is the landscape of my story. I only get to enjoy the real one when I'm done." I think Pericoli has drawn the views of writers at least partly because they are seers as opposed to lookers—*because* they blind themselves to their surroundings as a matter of practice. The drawings are addressed, first of all, to them, and their written responses are no small part of the pleasure this book has to offer. Each of these drawings seems to contain a set of instructions: If you were to look out this window—if you really looked—here is how you might begin to put the mess in order. Yet the order Pericoli assigns is warm and forgiving. His omniscience has a human cast. His clap-

boards wobble in their outlines. He takes obvious delight in the curves of a garden chair, or a jar left out in the rain, or laundry flapping on a clothesline. He prefers messy back lots to what he calls (somewhat disdainfully) "photogenic views." He knows that we are attached to the very sight we overlook, whether it's tract housing in Galway or a government building in Ulaanbaatar. These are the everyday things we see, as it were blindly, because they are part of us.

Some of the writers in these pages are household names. Many you will never have heard of, and a few live in places you might have trouble finding on a map. That, it seems to me, is part of the idea behind this book. Here are streets and alleys you won't recognize that someone else calls home and takes for granted; look long enough and they will make your own surroundings more interesting to you. In Pericoli's sympathetic—you might say writerly—acts of attention, the exotic becomes familiar, and the familiar is made visible again.

CONTENTS

PREFACE by Lorin Stein ... ix

WINDOWS ON THE WORLD by Matteo Pericoli 1

ORHAN PAMUK and Istanbul, Turkey 4

ETGAR KERET and Tel Aviv, Israel 6

JOUMANA HADDAD and Jounieh, Lebanon 9

ALAA AL ASWANY and Cairo, Egypt 13

CHIMAMANDA NGOZI ADICHIE and Lagos, Nigeria 16

ROTIMI BABATUNDE and Ibadan, Nigeria 19

BINYAVANGA WAINAINA and Nairobi, Kenya 22

NURUDDIN FARAH and Mogadishu, Somalia 25

LAURI KUBUITSILE and Mahalapye, Botswana 28

NADINE GORDIMER and Johannesburg, South Africa 30

LIDIJA DIMKOVSKA and Skopje, Macedonia 32

LULJETA LLESHANAKU and Kruja, Albania 34

TAIYE SELASI and Rome, Italy 36

TIM PARKS and Milan, Italy 38

DANIEL KEHLMANN and Berlin, Germany 40

CHRISTINE ANGOT and Paris, France 42

JON McGREGOR and Nottingham, United Kingdom 45

ANDREA LEVY and London, United Kingdom 48

MIKE McCORMACK and Galway, Ireland 50

LEILA ABOULELA and Aberdeen, United Kingdom 52

ANDRI SNÆR MAGNASON and Reykjavik, Iceland 54

KARL OVE KNAUSGAARD and Glemmingebro, Sweden 57

NASTYA DENISOVA and St. Petersburg, Russia 61

G. MEND-OOYO and Ulaanbaatar, Mongolia 64

HARRIS KHALIQUE and Islamabad, Pakistan 66

RANA DASGUPTA and New Delhi, India 68

XI CHUAN and Beijing, China 70

EMMA LARKIN and Bangkok, Thailand 72

RYU MURAKAMI and Tokyo, Japan 74

ANDREA HIRATA and Jakarta, Indonesia 76

RICHARD FLANAGAN and Bruny Island, Australia 79

CERIDWEN DOVEY and Sydney, Australia 83

REBECCA WALKER and Maui, Hawaii, United States of America 86

MARINA ENDICOTT and Edmonton, Alberta, Canada 88

SHEILA HETI and Toronto, Ontario, Canada 90

ELMORE LEONARD and Bloomfield Village, Michigan, United
States of America 92

GERALDINE BROOKS and West Tisbury, Massachusetts, United
States of America 94

BARRY YOURGRAU and Queens, New York, United States of America 96

TEJU COLE and Brooklyn, New York, United States of America 98

LYSLEY TENORIO and New York City, New York, United
States of America 100

JOHN JEREMIAH SULLIVAN and Wilmington, North Carolina, United
States of America 102

EDWIDGE DANTICAT and Miami, Florida, United States of America 104

T. C. BOYLE and Montecito, California, United States of America 106

MICHELLE HUNEVEN and Altadena, California, United
States of America 109

FRANCISCO GOLDMAN and Mexico City, Mexico 113

RODRIGO REY ROSA and Guatemala City, Guatemala 117

ALEJANDRO ZAMBRA and Santiago, Chile 120

TATIANA SALEM LEVY and Rio de Janeiro, Brazil 122

DANIEL GALERA and Porto Alegre, Brazil 124

MARIA KODAMA and Buenos Aires, Argentina 126

CONTRIBUTORS 129

ACKNOWLEDGMENTS 136

WINDOWS ON THE WORLD

MATTEO PERICOLI

It has been ten years since the day I paused in front of my Upper West Side window and noticed something. And *felt* something: an urge to take the view with me. I had looked out that window for seven years, day after day, taking in that particular arrangement of buildings, and now my wife and I were about to move out of our one-bedroom apartment. Without my knowing it, that view had become my most familiar image of the city. It had become mine. And I would never see it again.

It is hard to pay close attention to those things that are part of our daily routines. "They will still be there tomorrow." It is often when we are about to lose them or have just lost them that we realize their importance. It struck me as odd that I hadn't paid more attention to my view. That oversight made me wonder how we live and perceive what is outside our windows. About how we live and perceive, period.

For me, a window and its view represent a "reset button" of sorts. An instant, like the blinking of an eye, when I allow my brain and my thoughts to pause by wordlessly wandering outdoors, through the glass, with no obligation to analyze and, so to speak, to report back to my conscious self. My eyes simply gaze, without seeing, at a landscape whose subconscious familiarity allows for dis-

traction: the usual rooftops, the well-known moldings, the nearby courtyard, a distant hill. I look passively through the sheet of glass, which is a point both of contact and of separation between me and the world.

So, on that day in 2004, I finally paid attention to my window view. I tried photographing it but soon realized that the photos didn't work. They were not able to convey *my view,* but simply what was outside the window. And so I drew it, frame and all, on a large sheet of brown wrapping paper using pencils and oil pastels, and noticed for the first time the quantity of things I *didn't* know that I had been looking at for so long. Where had they been hiding in my brain?

Since then, I've spent years drawing window views. Between 2004 and 2008, while I was doing research for a book on New York City, I came to realize that writers often find themselves in a similar position to mine: Stuck at a desk for hours on end, they either position themselves near a window in order to take in as much as possible, or they consciously choose to protect themselves from it. And when I would ask writers to describe their views, something extraordinary happened: All the elements that I had been able to capture in my drawings were complemented (or, perhaps, even augmented) by their words.

This was the simple premise of the "Windows on the World" series, which started in 2010 in the *New York Times* and continued in the *Paris Review Daily:* drawings of writers' window views from around the world accompanied by their texts—lines and words united by a physical point of view. The fifty drawings in this book (some never published before) offer an observational platform, an "opening," you could say, a place to rest and meditate during a fifty-leg journey around the world.

After all these years, I have finally learned to pause for longer periods of time in front of windows and often wonder what it would feel like to have those views as mine. How would they affect me? Would I be the same if I were to look at *these* buildings or trees or boats passing by every day? I have come to feel that a window is, ultimately, more than a point of contact or separation with the outside world. It is also a sort of mirror, reflecting our glances inward, back onto our own lives.

Orhan Pamuk

Most of my writing time is spent forming the next sentence in my imagination. When my mind is busy with words, all by itself my eye moves away from the page and the tip of the fountain pen. This is the landscape I have gazed upon through my Istanbul window for the last fifteen years. On the left side is Asia and in the middle the Bosphorus and its opening to the Sea of Marmara, as well as the islands I have been going to each summer for fifty-eight years. To the right is the entrance to the Golden Horn and the part of the city that Istanbul residents refer to as the Old Town, home of the Ottoman dynasty for four centuries, including Topkapi Palace, the Hagia Sophia, and the Blue Mosque.

I sometimes proudly declare I am a writer who wrote a historical novel, *My Name Is Red*, set in a location constantly before my eyes. To the popular question inquisitive guests and visiting journalists ask—"Doesn't this wonderful view distract you?"—my answer is no. But I know some part of me is always busy with some part of the landscape, following the movements of the seagulls, trees, and shadows, spotting boats and checking to see that the world is always there, always interesting, and always a challenge to write about: an assurance that a writer needs to continue to write and a reader needs to continue to read.

ISTANBUL, TURKEY

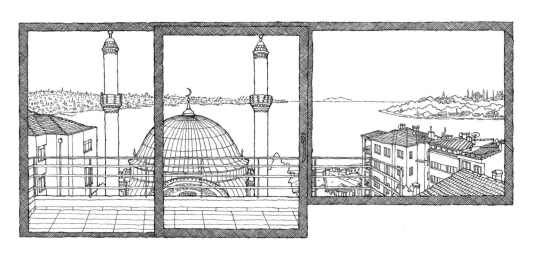

2010

Etgar Keret

The nicest place I ever got to write in was in MacDowell. My studio there was surrounded by a beautiful snowy forest, and looking out of the windows I could often see deer. During my residency there a friend came to visit. After having a beer together he said, "There is so much beauty around you, yet I can see from the angle at which your computer is placed that when you write all you can see is the toilet. Why is that?"

The answer was simple. When I write, what I see around me is the landscape of my story. I only get to enjoy the real one when I'm done. In the Keret family tradition my writing space is always one of the least desirable spots in our apartment, a place which only a person who is busy writing can bear. Currently it is a small metal table placed between the living room and the kitchen. The moment I stop writing I can notice on the other side of the road a beautiful grand tree allegedly planted sixty years ago by one of Israel's finest children's poets, as well as the happy mess my son and I left on the balcony the day before, but this is just for a moment; most of the time I just see my stories, which are usually much messier than the balcony floor.

TEL AVIV, ISRAEL

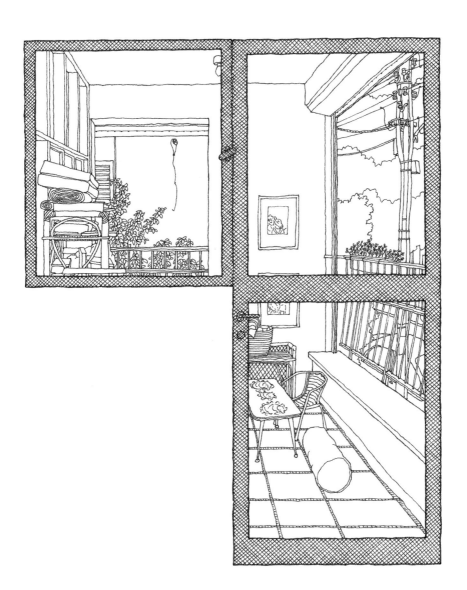

2012

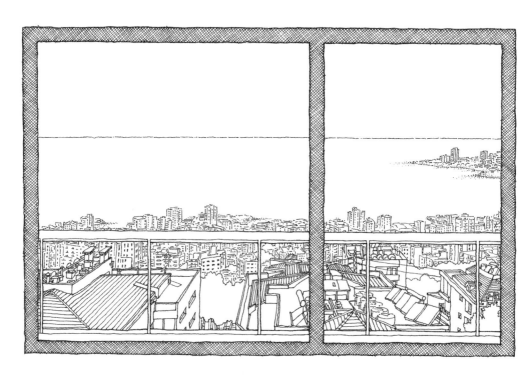

2014

Joumana Haddad

At the beginning there was a sea; a sea that saved a little girl from drowning; a sea that saved her altogether and represented to her the meaning of the word "freedom"; the same word that she was deprived of while growing up, and that she learned to snatch again and again with her fingernails all along her life; the same word that taught her to dream and to scream, in her head and on paper; the same word that is now tattooed in Arabic on the right arm of the woman she became; the same word that helps her stand up, every time she stumbles and falls to her knees; the same word that will be waiting for her, right there at the end of the journey, gleaming like a never-ending discovery.

Yes, at the beginning there was a sea. And the little girl, who was born and raised in a modest family that could barely afford to give her a good education, could only catch a glimpse of it from the balcony of their small apartment in one of the ghettos of war-torn Beirut. She had to climb on a plastic chair to actually be able to see it, but that's exactly what she used to do, obstinate, fearless, and most of all THIRSTY. To her it was a window on a better future, and she would promise herself, looking at it, that one day her life, and that of her parents, would be different; that one day she would wake up, open her bedroom curtains, and have the whole sea in front of her, with arms wide open to receive her loving gaze. A promise that she did, and still does, her best to keep, for the sake of that helpless, trapped little Joumana who used to fly away over the Mediterranean in her thoughts. "Sea, one day I will own you," she chanted in her head between the blasts of the militias' fights outside, and the frustrations of her personal fights inside . . .

Now, some thirty years later, as she sits by the window of the house of her dreams—a house that she fought long and hard to build—and as the blue coast of Jounieh is entirely displayed in front of her, she finally understood the lesson: The sea, just like the freedom she has been yearning for, can never be owned.

She learned that if you are lucky enough, they would be the ones owning you.

JOUNIEH, LEBANON

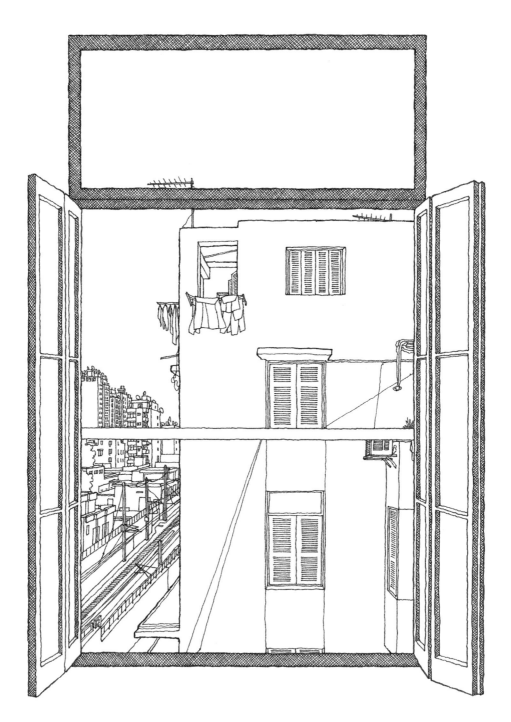

2011

Alaa Al Aswany

I open my window and this is the house, in the depths of central Cairo, that looks back at me.

The people who live in the city's working-class neighborhoods are not ashamed of being poor. Instead, in this house I look at from my window, I see heroic efforts in the fight against poverty. For the most part the residents are tradesmen or public employees. There was a time when they earned enough to enjoy a comfortable life, but the waves of hardship rose suddenly and they drowned.

Originally the window on the house's first floor was ornate glass. It was broken and repaired more than once. The last time, to keep costs down, the house's owner put up a piece of wood in place of the glass.

In prosperous times the members of the family would pass pleasant evenings in the open air in the house's entryway, relaxing on fine wicker chairs. The chairs broke and the father did not have the money for a new set, but he kept the shattered ones along the walls inside the entrance nevertheless. Another dream postponed, never to be realized. Just nearby is an opening in the wall for an air conditioner. The house's owner sealed it up and painted it over because he knows that he will never be able to buy an air conditioner.

The most beautiful things in this scene are the housedresses hanging on the second-floor clothesline. The cloth is plain and humble, but their owner did not give in. She put simple designs on their bodices and sleeves . . . they certainly seem more beautiful . . . and this is something I admire about resistance in the face of poverty. Poverty is wretched, but resistance to it brings forth a certain nobil-

ity. I have only to open the window and see this house to be overcome with a fierce compassion.

Despite the poverty creeping without pause or pardon, I see dozens of instances of humanity. A teenager writes his first love letter and hides it in a chemistry textbook so his mother won't see it. A girl locks her bedroom door and dances naked in front of the mirror. Young lovers exchange urgent kisses in the darkness on the roof. Nights of clumsy lovemaking in the first days of marriage. A baby's startled scream upon entering life and a haggard old man's voice shuddering a final time before he dies.

All windows, no matter the variety of scenes, convey to us nothing other than life.

(Translated from the Arabic by Geoff D. Porter.)

CAIRO, EGYPT

Chimamanda Ngozi Adichie

When my writing is not going well, there are two things I do in the hope of luring the words back: I read some pages of books I love or I watch the world. This is my view when I am at home in Nigeria, in the port city of Lagos. An ordinary view, with houses close together, cars crammed in corners, each compound with its own gate, little kiosks dotting the street. But it is a view choked with stories, because it is full of people. I watch them and I imagine their lives and invent their dreams.

The stylish young woman who sells phone cards in a booth next door, the Hausa boys who sell water in plastic containers stacked in wheelbarrows. The vendor with a pile of newspapers, pressing his horn, his hopeful eyes darting up to the verandas. The bean hawker who prowls around in the mornings, calling out from time to time, a large pan on her head. The mechanics at the corner who buy from her, often jostling one another, often shirtless, and sometimes falling asleep under a shade in the afternoon.

I strain to listen to their conversations. Once I saw two of the mechanics in a raging but brief fight. Once I saw a couple walk past holding hands, not at all a common sight. Once, a young girl in a blue school uniform, hair neatly plaited, looked up and saw me, a complete stranger, and said, "Good morning, ma," curtsying in the traditional Yoruba way, and it filled me with gladness. The metal bars on the window—burglaryproof, as we call it—sometimes give the street the air of a puzzle, jagged pieces waiting to be fit together and form a whole.

LAGOS, NIGERIA

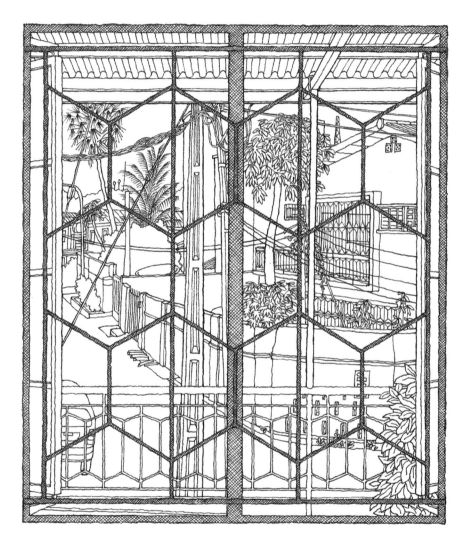

2010

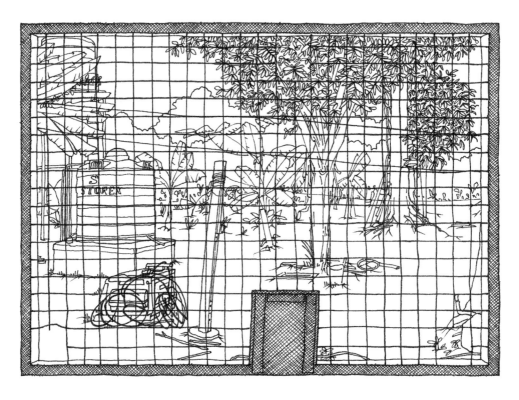

2013

Rotimi Babatunde

The green giants looking down at my writing table through the window must regard me with some affection because, till now, they have refrained from crashing down on my head.

Colonialist narratives would have had savages, noble or otherwise, beating drums all night long under their canopy, and international news channels would have had child soldiers or refugees materializing out of their undergrowth. However, in harmony with the fundamental drabness of human existence, nothing so dramatic ever happens here, except for the daring leaps of the squirrels from branch to swaying branch and the swiftness with which talons snatch skywards their unlucky prey, and, occasionally, a noise like the universe's thunderous obituary which rocks the earth when one of my green giants falls.

Against that verdant backdrop, only a run-down generator and two water tanks, reminders of the nation's contemporary challenges, strike discordant notes.

Perhaps the trees tweet in floral ciphers about the migratory patterns of birds or are Facebook friends with the creepers clinging to their trunks. And who knows if, for some curious reason, their boles course with arboreal bile against the Los Angeles Lakers or if they secretly root for North London's Gunners? And could it be possible that they dream of one day walking a dog down a deserted lane? One cannot be sure of these things, as one cannot also be sure if the trees will continue regarding me with affection, since the giants just keep standing there, regal and mute.

In this pocket of the vanishing rainforest nestled amidst the urban sprawl of one of Africa's most populous cities, sitting behind my writing desk which might be an ancestor to one of the trees observing it, I am thankful for the surrounding silence of the trees.

IBADAN, NIGERIA

Binyavanga Wainaina

I have lived in this cramped little cottage near Ngong Forest in Nairobi for the past year. After many winters abroad, I find myself unable to work indoors. Nairobi gets very cold in June and July, but I like to work free of the prison of the house. I love the tingling pullover of night sounds and forest sounds and the bite of cold breeze and distant cars and stereos. Sometimes I close my eyes and sway my arms into patterns to move with the sensations of the strong bitpieces banging about in my temples. The bitpieces are almost always word-based moods. They live and die fast. When the bitpieces catch characters or a probable course of narrative action, my fingers start to keyboard peddle furiously. If I stop, the whole world crumbles. If the bitpiece world crumbles, I stop. Days, sometimes bad-mood weeks, can go by before momentum is found again. Tennis helps. And fermented millet porridge. And my lover.

NAIROBI, KENYA

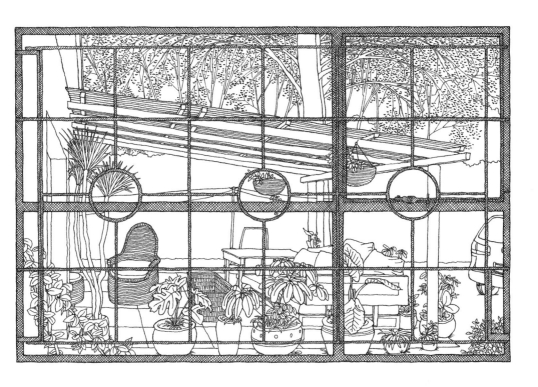

2012

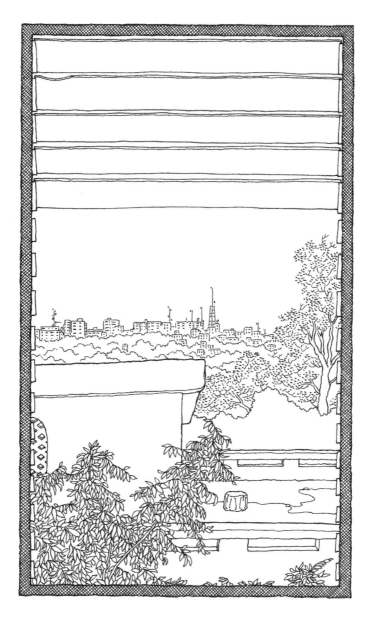

2011

Nuruddin Farah

Often I live in one place but write about another place very much unlike it. I wrote my first novel as a student in India, and I wrote my latest while commuting among Newcastle in England, Minneapolis, and Cape Town, where I reside. As befits a writer who lives more in the mind than in my physical surroundings, I base my work on memory, which I enrich with my knowledge of Somalia—where my novels are set—and supplement with my imagination.

When I start a work, I first visit Mogadishu to do research, then return just before publication. During this time the attitudes of the city's residents, their dress habits, and even their diet will have undergone changes, depending on the politics of the country's competing factions.

On a clear day, the beauty of the city is visible from various vantage points, its landscape breathtaking. Even so, I am aware of its unparalleled war-torn decrepitude: Almost every structure is pockmarked by bullets, and many homes are on their sides, falling in on themselves.

From the roof of any tall building you can see the Bakara market, the epicenter of resistance during the recent Ethiopian occupation; its labyrinthine redoubts remain the operations center of the militant Islamist group Shabab. Down the hill are the partly destroyed turrets of the five-star Uruba Hotel, no longer open. Now you are within a stroll of Hamar Weyne and Shangani, two of the city's most ancient neighborhoods, where there used to be markets for gold and tamarind in the days when Mogadishu boasted a cosmopolitan community unlike any other in this part of Africa.

So what do I see when I am in Mogadishu? I see the city of old, where I lived as a young man. Then I superimpose the city's peaceful past on the present crass realities, in which the city has become unrecognizable.

<div align="right">Mogadishu, Somalia</div>

Lauri Kubuitsile

I work in an office in the garden away from my house. My window looks out on a small patch of grass where our birdbath and bird feeder are located. I spend quite a bit of time staring out at the visitors to my small bird sanctuary. Birds, much like people, are unique. On a lucky day I'll have a visit from a small goshawk, a sparrow hawk. When he comes all the other birds clear off in fear, and yet he is the most frightened of all of them. He so desperately wants to play in the water, but spends all of his time scanning the air for enemies. Or I'll get the pair of Indian mynas, the neighborhood bullies, who fear nothing. Sometimes a crowd of blue waxbills will stop by, polite and accommodating, but too busy to idle long, or the clumsy Cape doves, one partner in the tree watching while the other takes a drink. My favorite is a crowd of joyful starlings that splash and play and leave soaking wet. It's relaxing to watch the birds as I search for the right word or sentence or plot twist. In many ways they're not so different from us I think.

MAHALAPYE, BOTSWANA

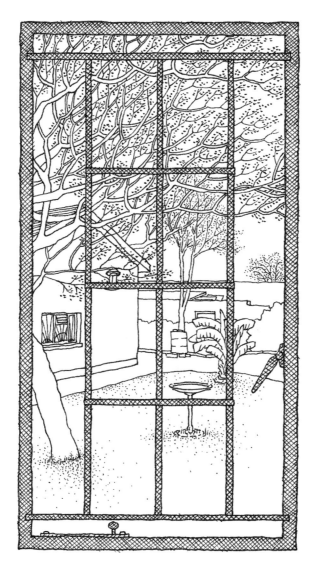

2014

Nadine Gordimer

The view from my window is my jungle.

A green darkness of tree ferns, calla lilies, luxuriant basil, the great cutout silhouette leaves of what is known as a "delicious monster" plant, all overgrown their tubs. Four frangipani trees, with delicate gray limbs with leaves and discreet sprays of flowers just now at their height, are an open screen on the jungle.

My desk is away to the left of the window. At it, I face a blank wall. For the hours I'm at work I'm physically in my home in Johannesburg. But in a combination of awareness and senses that every fiction writer knows, I am in whatever elsewhere the story is in. Two very different circumstances among my friends Mongane Wally Serote and Amos Oz come to mind as examples. Mongane Wally wrote poetry in solitary confinement in a prison cell during apartheid, work with a view far from prison walls; Amos Oz writes his illuminating novels of Israel within Middle East politics, history, and psychological states from a sort of cellar in his house.

I don't believe a fiction writer needs a room with a view. His or her view: the milieu, the atmosphere, the weather of the individuals the writer is bringing to life. What they experience around them, what they are seeing, is what the writer is experiencing, seeing, living.

We don't need a view; we are totally engaged in those views created by and surrounding the people we are getting to know.

JOHANNESBURG, SOUTH AFRICA

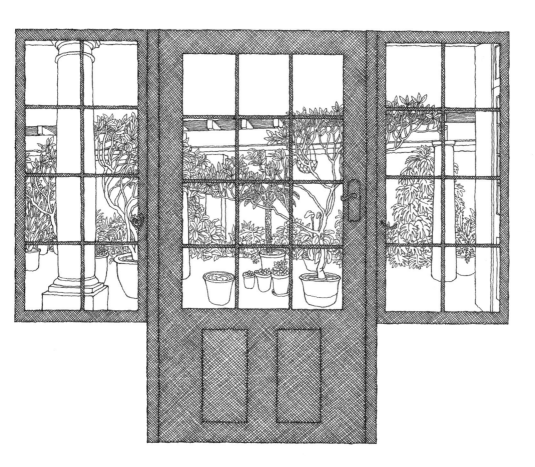

2011

Lidija Dimkovska

My late childhood and entire youth window. I began to write in front of this view, and while I am here, I still do, at a low, small table. On a typewriter then, on a laptop now, but preferably in a small note-book with lines.

I look outside often; the pictures have become very familiar. Two brothers used to live in the building with their families and their old mother, a small, tiny woman in black who always was screaming at her grandchildren, often beating them or running after them. They also were screaming, and that noise was present in the air until the parents would come home from work. Later, I found out that they moved the grandma from the first floor to the cellar, where she died. One of her daughters-in-law was Serbian; once, the Serbian woman sent me and my friends to the shop to buy her a special orange juice, Fructal. She opened it, and for the first time in my life I tried this juice that my family could not afford.

The roof of the building was always in my view. In the mornings a stork would come to the chimney on the roof and look through my window. We looked each other in the eyes, and we understood each other. He was my sky, I was his earth's friend. It was impossible not to write.

SKOPJE, MACEDONIA

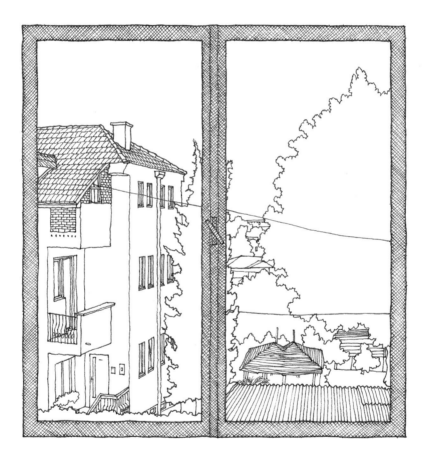

2013

Luljeta Lleshanaku

I usually prefer to write in my bedroom at my childhood home in Kruja. Traces of the old living style are in the yard in the front of the window: the sheets hung for drying; the terra-cotta jars, or *magrips,* sixty-year-old objects once used by my grandfather as olive oil containers and now cut at the throat, transformed as flower vases; the ruined walls which once fenced in the tomato garden; the alembic, or *lambik,* which served, in the absence of running water, for washing hands after work. But also present is the invisible, the unseen: the erased objects and the missing human beings; the cut plum tree where my sister and I used to climb up during those beautiful summer mornings; the loud voice of my mother when coming back exhausted from her work; the mulberry tree which brought the insects and the good odor of *pegmez,* the syrup of condensed fruit; the liming thresholds before holidays; my uncles, my cousins, all those portraits and gestures which once populated this yard.

On this inescapable, familiar stage, I can focus on the pelagic depth of a single and bounded situation. In my case creative freedom doesn't necessarily mean hunting for a new landscape. This environment leads me toward something unmistakable, which is a kind of freedom, too.

KRUJA, ALBANIA

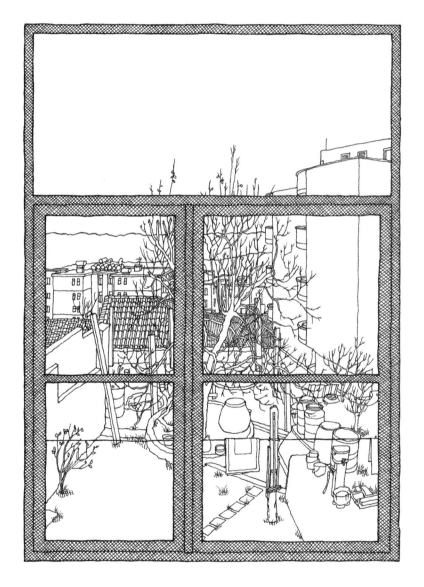

2013

Taiye Selasi

This summer I wrote my first ever article in Italian, considering why the Eternal City lures so many expat authors. In my limited Italian, I proposed three reasons—the beauty, the warmth, the unambitious-ness—all of which come to mind when gazing at this view. When the sun begins to slip behind the gilded greens of the Janiculum, I'll stare at the dome of St. Peter's Basilica, breathless every time. The sheer beauty of this ancient city—the scale of its churches, the density of its trees, the pastels of its façades, the voluptuousness of its clouds—is on full display from here.

My watch is the clock atop the Basilica of Our Lady in Trastevere, adding its chimes to the cheerful din of chatter, car horns, laughter. There's never a dull moment in the Piazza of Santa Maria in Trastevere; one can sense as much as hear the joy of social gathering. But it is Rome's imperfection that I find so beguiling, an invitation to play: seagulls squawking, *nonne* bickering, paint chipping from the walls.

ROME, ITALY

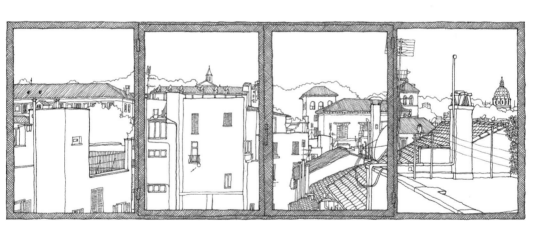

2013

Tim Parks

Do I pull up the shutter before my cappuccino or afterward? That's the first decision of each new day. I need to see if it's raining. The cord is worn and the shutter's slats will jam if yanked too hard. The view scrolls up. "View" is generous. This is an ordinary courtyard in a sixties condo in working-class Milan; my small balcony hangs over the building's main entrance, looking onto other small balconies above and to the left, some alive with plants, with dogs, cats, canaries, others storing old bikes, buggies, bits of furniture. In the middle of the space, a handkerchief of lawn and a tall horse chestnut, golden in midsummer, gaunt in winter, remind us of Nature. Otherwise it's all cement, stucco, and tiling. Not unpleasant, not oppressive, not exciting. After ten minutes in the café (across the street) where recent Chinese arrivals serve excellent coffee and croissants, I work with my back to the open window which lets in dogs barking, a young man iPhoning on his balcony, some challenged creature who yells sporadically down the street. The *portinaia* sweeps fallen leaves and cigarette stubs, chatting to all comers with unremitting enthusiasm. But I'm wearing earplugs; her voice is muffled. About ten-thirty the sun hunts me down and a bright boil of light finds out how long it is since I vacuumed the parquet. Too long. I frown and turn up the brightness on this other window I'm typing into.

MILAN, ITALY

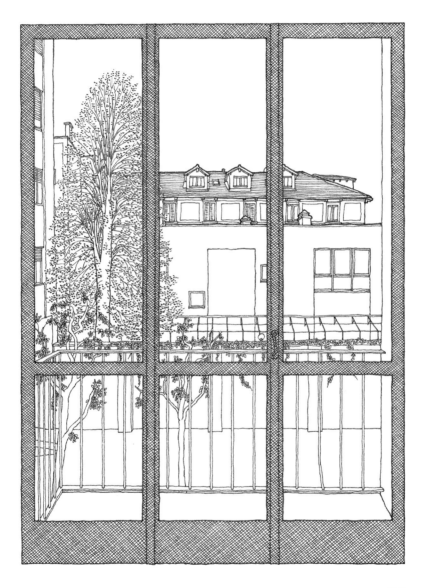

2012

Daniel Kehlmann

I try to ignore this view. When I'm at my writing desk I turn my back to it. When I look up—though these days one no longer looks up from his work, but merely past the monitor—I see only the spines of books along their shelves. What I don't see is the pitched window of the attic, the bend that the Spree, Berlin's main river, makes behind me, the distant façade of the magnificent Bode Museum; above all I don't see the three bridges with their streams of cars and pedestrians under which pass huge barges headed in both directions. Some of the barges carry freight, while others blast music as people dance and raise beer bottles on the deck, although on most of them sit tourists with their cameras, attentive as schoolchildren. I always wonder what they are photographing. The majority probably photograph the so-called Palace of Tears, that glass border-crossing station that once sat between East and West Berlin; today it is empty, although it will soon become a dance club. A few will also photograph the Berlin Ensemble, originally a theater founded and run by Bertolt Brecht; it is to the left of my window and visible only if I lean out. The most important thing, however, cannot be photographed: the invisible line where the Berlin Wall once stood. Absence can't be captured, not even with the best camera, and so the tourists turn their helpless devices to the gray façades of the new buildings, to the rows of identical windows, one of which, high up near the roof, stands open, and behind it a barely visible figure quickly turns away and goes back to work at his desk.

BERLIN, GERMANY

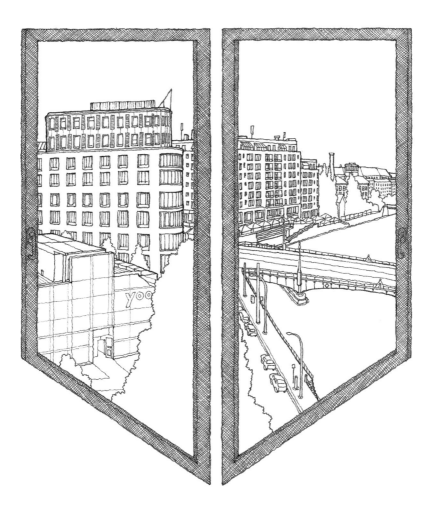

2010

Christine Angot

What I see from the window is what made me decide to take this apartment, I immediately thought I would see the garden from my desk, even if I no longer pay much attention once I am sitting in my chair, lowering the shades in the summer so as not to be blinded by the light, drawing them back completely in the winter to see the sky in full, looking at the slate roofs, worrying for the bamboo when the leaves turn yellow, turning the chair over when it rains, I have a connection with all that, more than with the few figures I happen to glimpse at their own windows, and I look, look often, look all the time, having the feeling that my eyes will never get the better of the swaying branches, or the little feet of the folding table, or the small heather flowers, I imagine the scent of lavender in the planter, and, when the seasons turn, I dream of speeding up or slowing down the changes, knowing that that will never happen, wanting in fall for the leaves to remain hanging high up in the trees as long as possible, hoping in spring that this time it will last forever, that the flowers will no longer fade, loving, at last, in autumn the glow that appears beneath the window, preventing my gaze from going beyond the railing in winter, trying to bear the bad mood of the short-tempered concierge who claims to be inspecting my way of watering the plants, resenting his warnings as doctrinaire, and a desire to spoil my happiness.

Paris, France

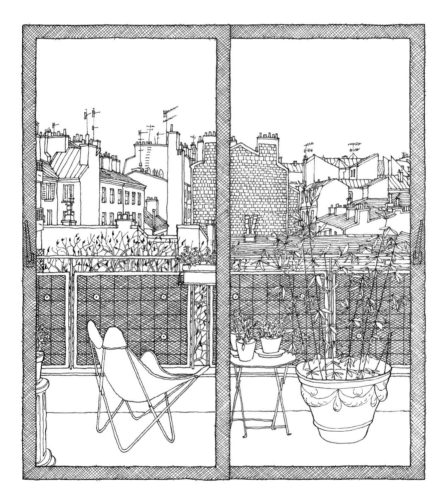

2014

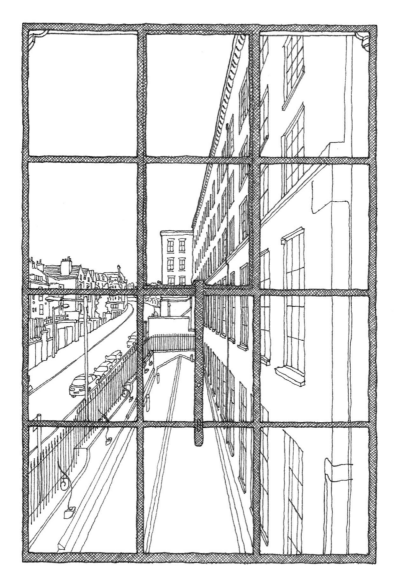

2014

Jon McGregor

About half the view from my window is the rest of the building I'm in, and the many windows from which other creative industry types are presumably gazing while they await inspiration. (At least, I imagine they're creative industry people. I don't actually know any of them; we pass each other in the stairwell from time to time, and avoid conversation.) It's a good-looking building; a lace factory built in the mid-nineteenth century, when they knew about proportions and symmetry and specified tall windows to let in the light. The rest of the view is taken up with whoever's coming and going in the street, and the row of once-grand houses opposite. These are the backs of the houses, the one-time tradesman's entrances; the frontages open into a broad green avenue which it's easy to imagine will one day be regentrified. For now, the tradespeople and the no-trades-people come and go through all the entrances.

There's a large security camera on the other end of the building, and I often see it pan and tilt. I wonder who's watching. Perhaps they're writing sonnets, and looking for inspiration.

At the top of the road is a fee-paying girls' school, and in the mornings the girls are hustled from their parents' cars to the school doors. They're all driven here. This isn't the kind of neighborhood where fee-paying school pupils live.

The parking regulations on the street are quite particular, and at least twice a day the parking wardens come racing by on their liveried scooters. There are two of them, and they seem very young and very pleased to be riding scooters for a living. When they issue tickets they do it quickly, glancing up at the many windows of the building behind them.

This is where I work. Obviously I don't look out of the window much, caught up as I am in the constant fever of creativity. But, you know. Now and again.

<div align="right">Nottingham, United Kingdom</div>

Andrea Levy

When I was young my mum used to complain that I spent too much time daydreaming. That was because I liked to stare at the sky. She thought that while I was dreaming I could be doing something useful as well, like knitting. Now that I am a writer, I have the privilege of daydreaming as part of my job. And I still love to gaze at the sky. The view from my workroom in my North London house has a lot of sky, and I couldn't work without it. There are never any structured thoughts in my head when I look up. They just come and go and change shape like the clouds.

I have a wonderful view of Alexandra Palace. This is not a royal palace but a nineteenth-century leisure center for exhibitions and events—a people's palace, known locally as "Ally Pally." It was the place from which the world's first regularly scheduled television transmissions were broadcast, in the 1930s, and the famous antenna is still there. Below it I can see the doors of the studios where modern television began, and I find that thrilling. The palace is still a venue for the occasional exhibition, but mostly it just sits there on the hill, waiting for someone to find a good use for it in this information age.

In the foreground, close to my house, is a school. I have come to know the sounds of that school so well that it has become my clock. As early as seven-thirty the first children arrive, twittering into the playground like the first birds of the morning. During the din of their playtimes I always stop working to have a cup of tea.

The school sits among Victorian row houses just like mine, with their jumbled chimney pots and television aerials. When I see them under my mass of sky, with Ally Pally up on the hill, then I know I am home.

LONDON, UNITED KINGDOM

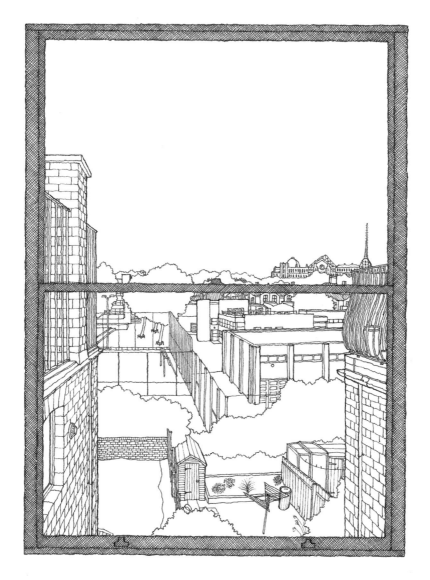

2010

Mike McCormack

I have lived in this house on the edge of Galway City for over five years now, and for a couple of hours a day I sit with my feet up on the windowsill and look out over this cul-de-sac. And no matter what time of day I sit here it always seems to be the middle of the afternoon. The place is constant, not given to mood swings or tantrums, just that tree and the sweep of tarmac which curves along by the green, nothing much to hold the eye or interest. Of course this is precisely the kind of stillness in which the mind's eye gets lost— vista as vortex. From time to time the stillness is broken up by a car or a child or a stray dog crossing the green. Sometimes a ball rolls into view. These are all quietly interesting but sooner or later they meld into the stillness of the place.

Today it's raining—patient, steady rain which will keep falling into the night. That's December rain, nothing new or unusual about it. Beyond the rooftops the sky has lowered down in heavy gray folds. Two years ago we had snow here for the first time, and for nearly a month the whole place was blanketed in soft whiteness. And while snow added little to the stillness of the place, for a short while it looked like it was elsewhere.

GALWAY, IRELAND

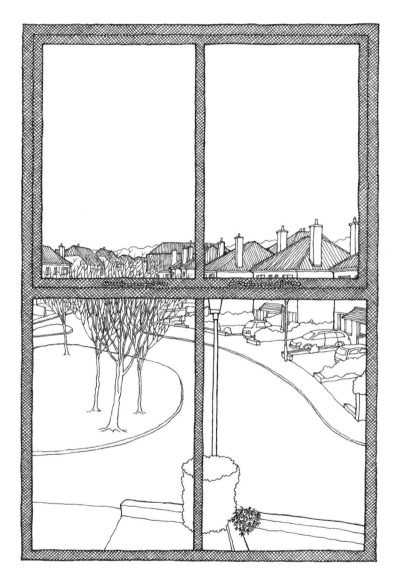

2012

Leila Aboulela

When we first moved here in September, the tree outside the window was green and I imagined I saw a navel orange dangling from one of its branches. This turned out to be the first cluster of autumn leaves. Aberdeen is noted for its granite buildings and I first encountered these chimneys in novels because when I was growing up in Sudan we had no need for heating. All my novels were written in different countries—in Doha, in Abu Dhabi, in Jakarta—but I wrote my first novel in another part of Aberdeen. In Jakarta I wrote about London and in Abu Dhabi I wrote about 1950s Sudan. The view from the window never encroached on the writing because the novels were incubating long before that particular move.

It is good to write and then look up at the sky, at the uninterrupted view of the tops of houses. When I am on a roll, there is a pressure of meanings clambering to be words, there is a gush that needs to be controlled or at least manipulated and the respite from this turbulence is always the clean familiar sky.

From this window, I saw the leaves dry out and fall, pulled by the November wind. Now it's March and I'm curious to see the first green leaf. I am geared up to witness a renewal. This anticipation is a faith exercise. Every day I train myself to believe that this tree will bloom; every day I remind myself that what is dead can come back to life again.

ABERDEEN, UNITED KINGDOM

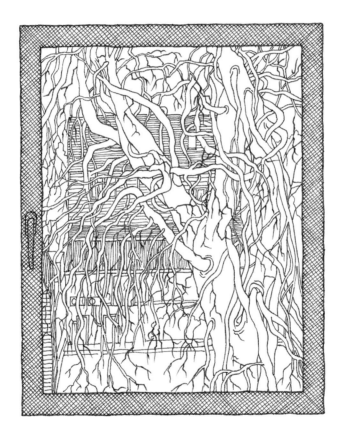

2013

Andri Snær Magnason

This is my window. Or my windows—the view from my living room, where I sit and write. Might not seem very inspiring. I wish I could offer green mossy lava, roaring waves, a glacier mountaintop. I do have other spaces—in an abandoned power station, a favorite fisherman's café by the harbor, a summer house on the Arctic Circle—but this is my honest view, what I really see most of the days. This house was built in the 1960s when people were fed up with lava and mountains; they were migrating to the growing suburbs to create a new view for themselves. The young couple who dug the foundation with their own hands dreamed of a proper garden on this barren, rocky strip of land. They dreamed of trees, flowers, shelter from the cold northern breeze. What is special depends on where you are, and here, the trees are actually special. They were planted fifty years ago like summer flowers, not expected to live or grow more than a meter. The rhododendron was considered a miracle, not something that could survive a winter. It looks tropical, with Hawaiian-looking pink flowers; Skúli, the man who built the house and sold it to me half a century later, took special pride in it.

I am not a great gardener. We are thinking of buying an apple tree, though they don't really thrive in this climate. I would plant it like a flower, not really expect it to grow, and hope for a miracle.

REYKJAVIK, ICELAND

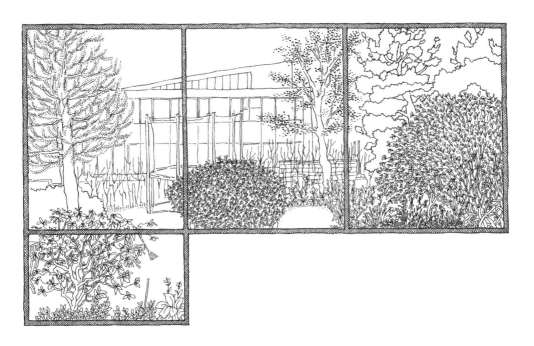

2013

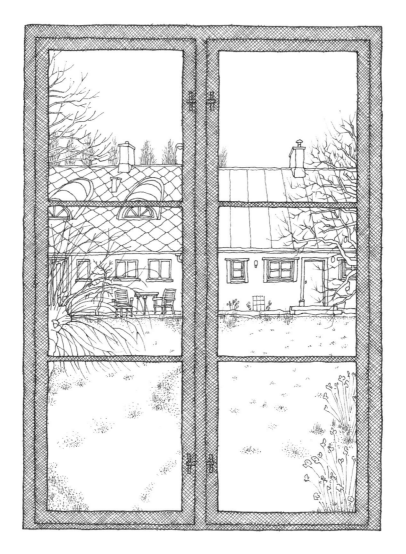

2014

Karl Ove Knausgaard

I love repetition. I love doing the same thing at the same time and in the same place, day in and day out. I love it because something happens in repetition: Sooner or later, the heap of sameness, accumulated through all the identical days, starts to glide. That's when the writing begins.

The view from my window is a constant reminder of this slow and invisible process. Every day I see the same lawn, the same apple tree, the same willow. It's winter, the colors are bleak, there are no leaves, and then it's spring, the garden is bursting with green. Even though I see it every day, I'm not able to notice the changes, as if they take place in a different time frame, beyond the range of my eye, in the same way high-frequency sounds are out of reach of the ear. Then the slow explosion of flowers, fruits, heat, birds, and insane growth we call summer is here, then there's a storm, and the apples lie in a circle under the tree. The snowflakes melt the instant they touch the ground, the leaves are brown and leathery, the branches naked, the birds all gone; it's winter again.

In my youth, I considered Cicero's claim, that all a man needs to be happy is a garden and a library, utterly bourgeois, to be a truth for the boring and middle-aged, as far as possible from who I wanted to be. Perhaps because my own father was somewhat obsessed with his garden and his stamp collection. Now, being boring and middle-aged myself, I have resigned. Not only do I see the connection between literature and gardens, those small areas of cultivating the undefined and borderless, I nurture it. I read a biography on Werner Heisenberg, and it's all there, in the garden, the atoms, the quantum leaps, the uncertainty principle. I read a book about

genes and DNA, it's all there. I read the Bible, and there's the voice of the Lord God walking in the garden in the cool of the day. I love that phrase, "in the cool of the day," it awakens something in me, a feeling of depth on sunny summer days that hold a kind of eternal quality, and then the winds from the sea come rushing in the afternoon, shadows grow as the sun sinks slowly on the sky, and somewhere children are laughing. All this in the cool of the day, in the midst of life, and when it's over, when I'm no longer here, this view will still be. This is also what I see when I look out my window, and there's a strange comfort in that, taking notice of the world as we pass through it, the world taking no notice of us.

GLEMMINGEBRO, SWEDEN

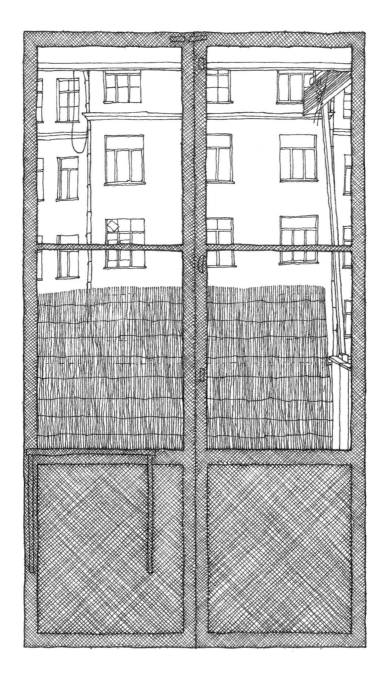

2014

Nastya Denisova

I've been living here for four months. The center of the city. Fifth floor. I usually look out the window at night, but it's not exactly a window—it's the door of a balcony. I can see all the windows of the building opposite mine.

I see how, from a window on the right, they regularly throw out plastic bags of trash onto the roof of the one-story building in the courtyard. But I don't know from which window, exactly—I follow the bags, and when I shift my gaze to the windows they're all closed, identical, except for the one that has a piece of green plywood instead of glass.

From a window on the left side of the building, people throw garbage without bags. Brown plastic beer bottles and, for some reason, heaps of metal tops from jars of homemade preserves. I see the man who throws all this from the window of his kitchen, leaning out the window and looking down. He looks down and spits. His cigarette butt has set some dead grass on fire. He spits for a very long time. He goes out and comes back with a bottle of water. He pours down the water. He throws the bottle out.

In the windows of the second floor are the kitchen and the back rooms of a restaurant. They're always throwing cardboard boxes out the windows. When the boxes start to block the little back courtyard, someone piles them up and they disappear. In the winter, covered in snow, the boxes become monolithic, angular snow architecture. And if you didn't already know, you wouldn't be able to say what they are.

From the window opposite me, cheerful teenagers fling DVDs. Maybe it's a dorm room. Are they using them like throwing

stars, or just tossing DVDs out the window? Have they noticed me? Two discs land on the balcony, through the door that I've been watching. Someone has drawn large, colorful butterflies on their surface.

(Translated from the Russian by Sophie Pinkham.)

ST. PETERSBURG, RUSSIA

G. Mend-Ooyo

When I was young, every morning I would take our hobbled horse and walk it in the dawn light. My father would say, "Sleep late like a horse. Rise early like a bird." As I walked with the horse, I was very happy to have the little birds fly just above the light of dawn as they sang.

The rhythm of each morning of my life still moves to the beat of my lovely childhood. From the window of my home in the center of Ulaanbaatar, I grasp the pale light in the east. Just as I used to bring in the horses pastured on the wild steppe, I spend time recollecting in my mind many thoughts that have taken flight. The images of life, transected by the window, are a chiaroscuro.

I can clearly see the great seat of learning that is the National University of Mongolia. Sometimes it seems to be an image hanging on walls. A few steps from the window is my writing desk, made from Mongolian pine wood. When I sit at the desk, the world shifts into a different space. The history books grow thicker. There is no time to watch what goes on beyond my window.

ULAANBAATAR, MONGOLIA

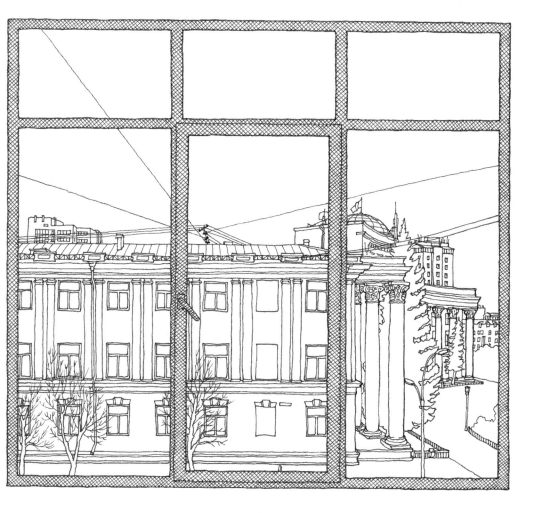

2013

Harris Khalique

In the afternoon when the sun is blazing and in early evening when its orange hue allows me to stare into the horizon, I look out of this window in my office that opens into a terrace but offers a wider view. I see the palatial houses and imagine the few who live there in luxury. Then I think of the many who serve them—who hurl rolls of newspapers onto their porches, bring groceries, drive cars, sweep floors, toil in the sizzling kitchens. They dwell in shanty settlements ensconced within the affluent neighborhoods or live in crammed quarters in the backyards of these houses.

Before dusk I can look beyond the trees and catch a clear glimpse of the thin-looking white minarets of the Faisal Mosque, one elegant and expansive structure on the slopes of the Margalla Hills. These minarets remind me of the worst dictator we have had. He lies buried in the gardens of this mosque while we still struggle to rein in the beasts of ignorance and bigotry he unleashed.

Last week when it stopped raining after several hours, I decided to go beyond the window and walk across the terrace to look over the street from above. I saw a young girl squatting by a small puddle and folding paper into boats. An odd mix of intense sorrow and great hope enveloped my heart.

ISLAMABAD, PAKISTAN

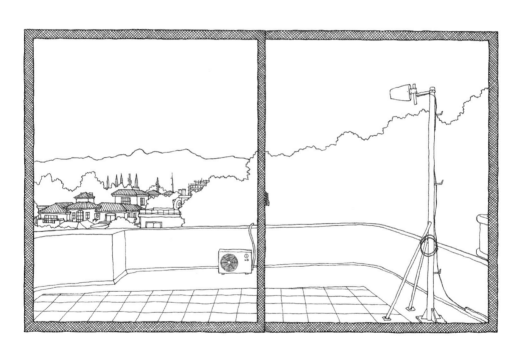

2013

Rana Dasgupta

I have come to realize that I do not love solitude as much as I think. It is always with happy anticipation that I arrive in my study: alone, at last, to write! But once the door is closed I have a paradoxical sense of loss, as if I am cut off from my source. Is this why I spend such an unreasonable amount of time staring out the window?

The rampant energy of Delhi, this city of almost twenty million people, presses in on my leafy street. Most families around here arrived as refugees from the horrors of India's partition in 1947. To protect themselves from such a thing ever happening again, they built solid rows of houses—which are nonetheless turning to vapor in the white heat of the city's twenty-first-century economic boom. One of the houses in this drawing has already disappeared, to be replaced, inevitably, by another block of flats. In the top left you can see the steel zigzags of Nehru Stadium, centerpiece of the 2010 Commonwealth Games, whose preparations involved a stupefying scale of destruction and rebuilding around the city.

The street is always active. A young turbaned Sikh paces unceasingly on the balcony opposite, talking on his mobile phone. Migrant laborers working on the new buildings have built lean-tos around the corner; their wives forage for firewood downstairs while their children play with a ball nearby. Passing vegetable sellers sing their wares. Dogs bicker. An old man sits outside in the sun to get a shave from a barber. Neighbors argue over parking spaces.

The silk cotton tree at the center of my view, however, is mute. It saves its energy for the spring, when its vast, red, syrupy flowers will rain, indecently, over everything.

NEW DELHI, INDIA

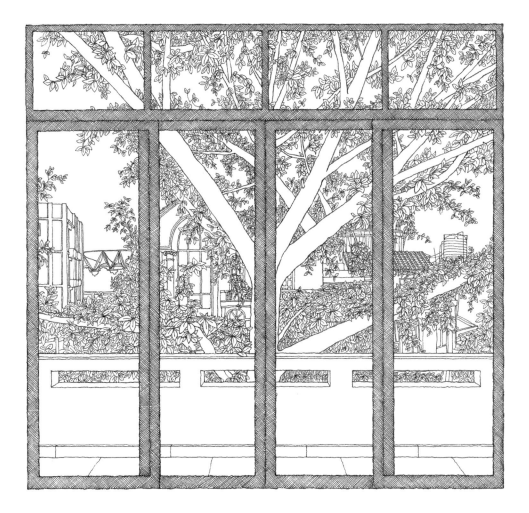

2011

Xi Chuan

This is one of three windows in my study. The study is a one-bedroom apartment on the fifteenth floor. I don't know how many stories this building has—probably twenty-five or more—but I have never been above the seventeenth floor.

During the day, if I don't need to be at school, I stay in my study. It is crowded with books and old objects I collected from flea markets. I don't have many friends visit me. I used to have a neighbor who was the manager of a small company that installed central heating. He occasionally came to talk with me, and I discovered that he had been a lover of poetry when he was young. I am sure he didn't know who I was, though, so I told him that I was a teacher of literature, which is true.

The window faces east. When I sit at my desk in front of a wall of books, writing, the window is to my left. When I bought this apartment, which is a fifteen-minute walk from my home, in the late 1990s, the building standing in front of my window was already there, as was the bridge, but the building behind the bridge was not, so there was a vast view across the city. But the whole city of Beijing was a giant construction site in the 1990s and 2000s, and the view couldn't last. Once I got used to the buildings in the window, I seldom looked out of it. No trees can reach the fifteenth floor, so no birds perch at my window. When I look out, I see cars running on the bridge. Nothing else.

BEIJING, CHINA

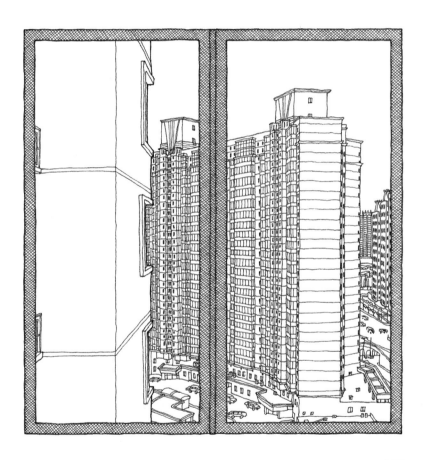

2012

Emma Larkin

My study window looks out over an incongruous jungle located in the heart of Bangkok. As the rest of the neighborhood is dominated by high-rises and town houses that have sacrificed yards for concrete parking spaces, all remaining wildlife seems to gravitate to our garden. Myopic fantail birds tap against the windowpanes, squirrels chew on the frayed corners of the shutters, and neon-green tree snakes sunbathe silently in the rain gutters. (I keep the number of a local snake catcher in my phone, as the lack of rats suggests the presence of a well-fed python somewhere in the vicinity.)

There is another type of wildness here, too. The ficus tree on the right-hand side of this drawing is where the house spirits now reside. At the advice of a fortune-teller, a tricolored band of cloth was tied around its trunk not long after we moved in. In accordance with Thai custom, regular offerings of food and flower garlands are laid out for the spirits so that they might be enticed to exist *outside* the house, rather than inside—a practice that has put a stop to most (but not all) of the inexplicable shadows and footsteps that flit through these old wooden rooms.

This scene encompasses both the wild and the urban, the known and the unknown. It reminds me that the dividing line between fact and fiction is less clearly defined here in Thailand and that the boundary between the two is porous. In such a place, stories thrive.

BANGKOK, THAILAND

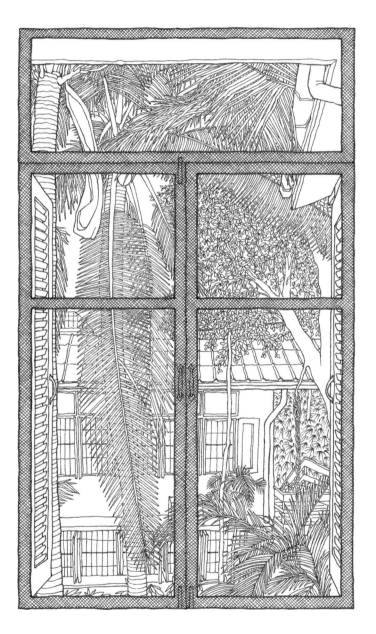

2012

Ryu Murakami

I often stay at a high-rise hotel in the Shinjuku district of Tokyo to write. From the window of my room, I can see both a new skyscraper and a big park. When I look at the skyscraper, I think about the people who died before it was finished and never got to see it. It's like a visual image of the truism that once you're dead, there aren't any more new sights for you. A lot of homeless people live in the big park. The blue vinyl tarps of their crude shelters are clustered throughout the grounds, but from this window all you can see are the leafy green trees.

(Translated from the Japanese by Ralph McCarthy.)

TOKYO, JAPAN

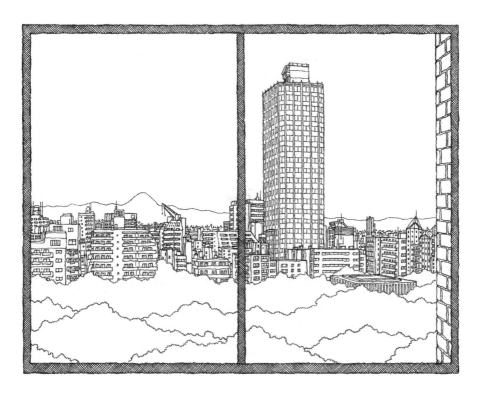

2010

Andrea Hirata

Since my childhood, I have rarely had the power to control where I can be. Life has not given me many choices. But after writing my first novel, I started thinking of leaving my place of employment, where I worked for almost twelve years. Though writing is a very risky way of making a living in Indonesia, I finally resigned from my job, and now I've got this strange feeling of relief.

The decision to write full-time meant I couldn't afford to buy a house. A friend kindly offered me the use of his apartment in a thirty-six-story building full of newlywed couples in the southern area of Jakarta. I didn't like my working space at first, but the scenery and everything going on outside have worked their magic on me. From a building right in front of my windows, I can observe the speed of the sunrises and sunsets. The voices of children playing, laughing, yelling, and crying on the playground crawl up to the eighth floor, where I write. Their voices sound so innocent from a distance.

JAKARTA, INDONESIA

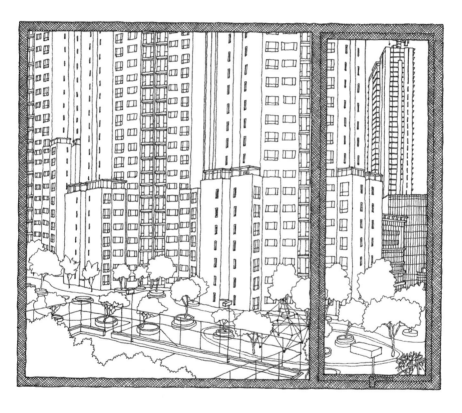

2013

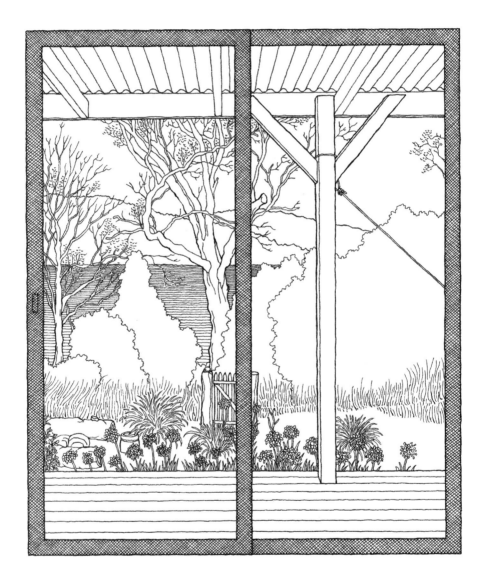

2011

Richard Flanagan

Unable to start writing, I look out past the veranda shadow. From my house on Australia's Bruny Island—named in Year 1 of the French Revolution by a French royalist after himself—I can see Tasmania, home to a human civilization for ten thousand years before modern man arrived in France.

Just out of view on the left is a cove. There, in a remote outstation, less than sixty years after the visit by Bruni d'Entrecasteaux, that civilization's forty-seven spirit-shocked survivors were dumped by the colonial authorities and left to die. After hearing of their story—he called it a "war of extermination waged by European immigrants"—H. G. Wells wrote *The War of the Worlds,* in which Martian immigrants exterminate Europeans.

In front, forty-spotted pardalotes sport in the white gum trees. They live off the sugary secretions on the trees' underleaves, but because of global warming the white gums are dying. Of these tiny birds, no bigger than the giant moths that come out at evening, fewer than a thousand remain. In a decade they may be gone.

The fences that once kept the fairy penguins from nesting beneath the house are gone, because the last of the penguins failed to return six years ago. No one knows why. All that remains is a closed gate.

Below are sandstone bluffs and kelp-wracked beaches reeking of forbidden things. Gone too from the sea here are fish like the trevally and cod and trumpeter. No one can explain that either. Sometimes I dive on the shallow reefs here, looking for words.

Hidden from sight too is Kel the carpenter, descended from one of the forty-seven survivors, ostensibly fishing and probably just

drinking up a beer and the sun and the light and the sound of water, the irreducible elements that remain. If he catches a good fish, he has promised to bring it round and we will grill it on the fire pit next to the aloe vera plants.

Bruni d'Entrecasteaux, perhaps in fear, or wonder, or both, called Bruny Island a place "separated from the rest of the universe."

No more though.

And at this end of a view of what cities wreak but which no city ever sees, my eyes fall, the cursor winks, and I begin.

<div align="right">Bruny Island, Australia</div>

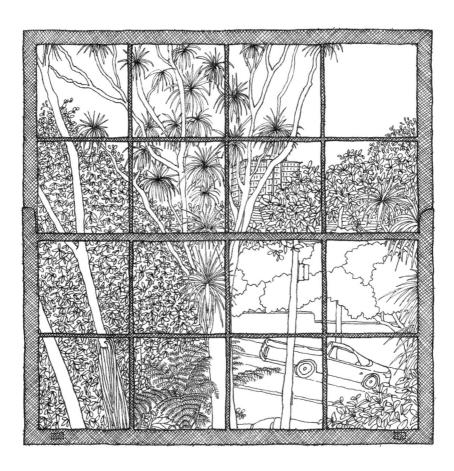

2014

Ceridwen Dovey

These days, I often write after dark, something I never used to do before my son was born when I had the luxury of working during my brain's freshest daytime hours. Now I'll take any hour I can get, day or night (but mostly night). The towering high-rise building in the distance, behind the palms, has been transformed from an aged, shabby hotel into a glass spaceship filled with new apartments, and until recently it was uninhabited. But lately I've been watching the apartments come to life with light at dusk, one by one, as the new owners move in and start to live their lives up in the sky. This part of Sydney has been subjected to intensive residential densification over the years, unstopped by the economic recession (which Australia dodged in some part, due to the minerals boom)—these massive apartment complexes turn up almost overnight like mushrooms along the Pacific Highway, many of them bought by Chinese property investors who have never set foot in Australia, as a kind of insurance against a future Chinese economic bust. Locals tend to feel very strongly about these high-density apartment complexes. For some, they represent the beginning of the end, the lowest point of Sydney's ridiculously overpriced property market; for others, they make urban sense—for a crowded city cordoned off to the north, west, and south by national parks and to the east by the ocean, the only way to grow is up. My response is more personal: I lived very happily in just such an apartment complex nearby for years, as did my parents. So I've been comforted watching through my window at night as the lights have been switched on, the glow of various lamps and overheads and bulbs as different as the lives

of the inhabitants within. Each light-scape is unique, each life is unique, but our days and nights follow a similar pattern: Most of the lights are switched on at dusk, and most are out by just before midnight.

<div align="right">SYDNEY, AUSTRALIA</div>

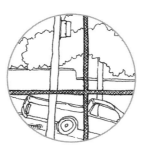

Rebecca Walker

I have been looking out this window for three years. I have stared out of these rectangular panes full of hope and also despair, giddy with inspiration to connect and overtaken with a throbbing desire to disengage. I suppose this is what writing is to me: gripping the rope that swings between reaching out and pulling in.

But whatever my mood, I have always loved the light beyond this window. I have always loved the quiet. I have loved my two empty chairs, sentinels awaiting their visitors, open to the promise of more. I have felt at home in this spot, on this road to the small village of Hana, on this tiny piece of rock in the middle of the Pacific Ocean. I have loved the rain that pours down, thunderous and crashing, before sunshine, harsh and stunning, pierces through once again.

It so happens that I am leaving home this very week. My view is changing. I am moving on and forward to my new house of words. I say goodbye to this window with gratitude and relief. Ready for the next chapter.

MAUI, HAWAII, UNITED STATES OF AMERICA

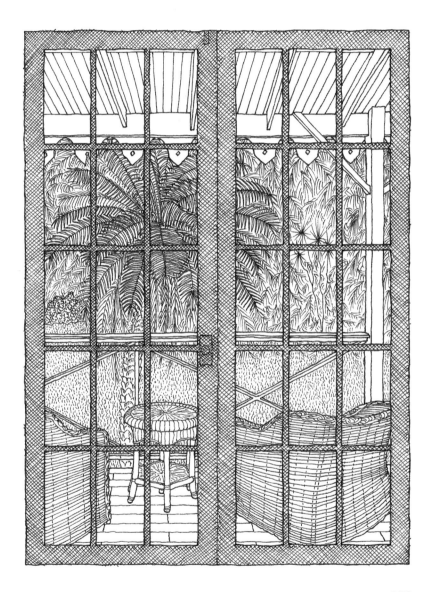

2013

Marina Endicott

By some spiral of fate and capitulation, instead of a street in the East Village or a shabby lane in London, I stare out at a suburban patio, a generous and quiet garden in Edmonton, Alberta.

Since buying this house from Ozzie and Harriet three summers ago, we've pretty much given the yard back to the squirrels and the magpies. People appear only as tops of heads walking down the alley, a zoetrope's glints through the fence. Because I haven't figured it out properly, the sprinkler comes on at odd hours, a sudden shower of inspiration or damping of pretension.

From inside, the garden looks like a reward: the drink on the terrace that is much more delicious in anticipation. But I turn away from the window. My desk faces a wall covered with images, notes, timelines, vaudeville photographs, and playbills; my keyboard sits in a small black space surrounded by piles of books and paper—the brain disgorged and arrayed. It's a world frantic with life, all that paper funneling gradually into the computer screen.

When my eyes blear and I cannot focus any longer, the window is a way for my mind to blink, to clear my vision.

In wintertime I look out at the nothing that is not there; in summer, at an imaginary peaceful life. Early in the morning, I could drink coffee there, reading pages or doing some writerly thing with a fountain pen. But in reality, pernicious mosquitoes make it impossible to sit and work outside. It is a vision of the original Garden, and just as unobtainable.

I go to my desk and work. Like the street in the East Village, the garden goes on without me.

EDMONTON, ALBERTA, CANADA

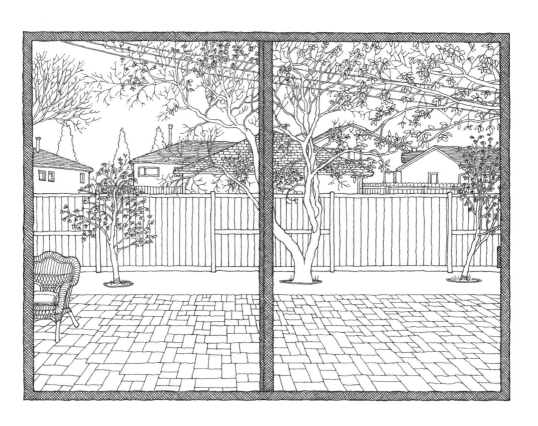

2011

Sheila Heti

Can you see that beautiful shrub? It has no bald patch, right? That's because the shy, moustached Portuguese man, who seems to live in that house alone, has spent the last six years standing in front of the hedge, where there was for so many years a bald patch. He'd stand before that patch, staring down at it for hours every day, even in the wintertime. When I'd come home from my errands and lock my bike to the pole, he would be there. When I went outside to check my mail, or if I looked up over my laptop, he would still be there.

At first I thought he was crazy. Then I began to think of him as more profound than other men. Why should we look at everything all around us? There is enough in a shrub.

This summer, the patch filled itself in. I guess he knew all along that it was not lacking water or fertilizer or chemicals or conversation. All it wanted was his attention. Now he stands at another empty patch.

I sit in a room lined with books, at a round teak dining table, on the second (top) floor of a Victorian house. He stares at his shrub as I stare at my computer. His body faces me and mine faces him. Our bodies are opposite each other every day, and we stare at things, and wait for the emptiness to fill in.

<div align="right">Toronto, Ontario, Canada</div>

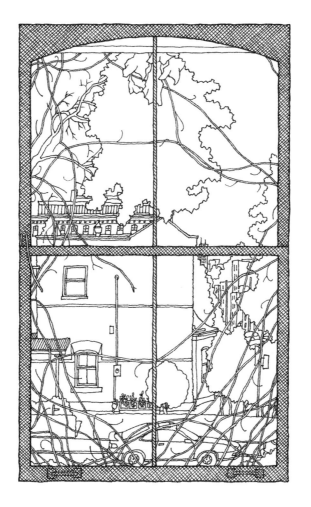

2012

Elmore Leonard

I sit here, in a suburb of Detroit, writing books by hand on yellow unlined pads with a view from my desk that offers distractions: Disney creatures on the patio, squirrels that come up for a handout and go nuts when I offer pistachios. Once I looked up from my work and a coyote was staring at me from the hedge a dozen feet away, though not with much interest. The squirrels know he's there and stay hidden and the coyote wanders off, hoping to find a little dog in another yard. Several times I've seen a hawk, claws wrapped around the limb of an apple tree, waiting for prey who somehow know better than to reveal themselves. Distractions are good when I'm stuck in whatever it is I'm writing or have reached the point of overwriting. The hawk flies off, the squirrels begin to venture out, cautious at first, and I return to the yellow pad, my mind cleared of unnecessary words.

BLOOMFIELD VILLAGE, MICHIGAN, UNITED STATES OF AMERICA

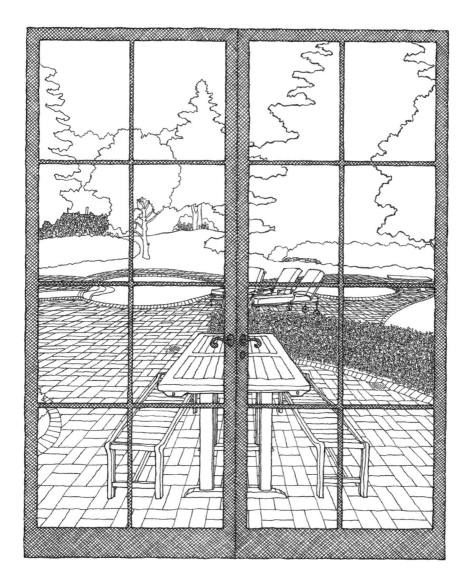

2011

Geraldine Brooks

The water never stops. The silver fall of it, the white churn of foam, the swirl and eddy smoothing out into the onward rush of the brook. There was a gristmill there once. In 1665, Benjamin Church, an English settler, dammed the little brook that the Wopanaak Indians of this place named the Tiasquam, harnessing the power of the waterfall to turn massive grindstones. The mill's been gone for a couple of decades, the grindstone set as a doorstep at the entrance to my house. The dairy cows that once grazed the field are gone too. Since the only industry that happens here now is the work of my imagination, the wild things have their stream back. Infrequently, I'll catch a glimpse of river otters sliding down the slick wet grass of the dam and muskrats browsing the banks. More common are the big snapping turtles—ancient, scarred-shelled veterans, who haul themselves out of the water to bask. Sometimes I'll let my mare loose to graze under the cedar tree, but not too often: I want to protect the stream and let the wetland plants regenerate. One day, maybe, I'll undo Benjamin Church's work completely, tear down his dam and let the water find its natural course. Maybe then the herring will come back each spring, swift silver schools shimmering upstream to spawn.

WEST TISBURY, MASSACHUSETTS, UNITED STATES OF AMERICA

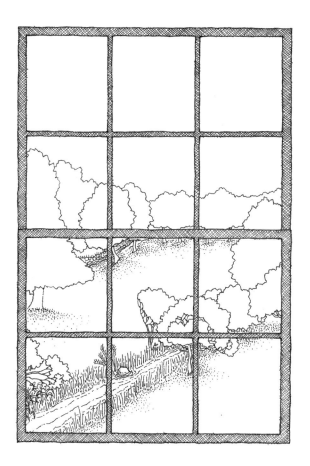

2013

Barry Yourgrau

The view from my window is pretty awful. I'm at my building's rear. I look straight at another building's rear. When I stand gazing out (not often) I feel like a Peeping Tom and an exhibitionist. My neighborhood, Jackson Heights in Queens, is where the concept of "garden apartment building" originated. My building isn't one of those. Neither is the building I face.

My place is dim. As someone who craves sunshine and vistas, I can't say I'm wildly happy here. Admittedly, when this was my girlfriend's apartment, she made everything cozy. She likes dimness: She's Russian, she explains. Then she bought a condo nearby and I took over the place as my writing studio, as somewhere to keep my things . . .

We travel a lot. My girlfriend is an international restaurant critic. I return laden with postcards, calendars, hotel stationery, posters, soccer scarves, beach wraps, etc. These mementos comprise much of the colorful dusty spectacle that has increasingly swamped my apartment.

The travel stuff is only part of it. I long had a storage space in Manhattan. There I kept, among other things, boxes of the books once in my late father's library. Now I have my apartment. Now the never-opened boxes lie bulging under a dusty Mexican blanket beneath my girlfriend's old colorfully draped dusty piano here. Buried but undead.

So my clutter, this side of my window, and dust are a problem. Odd how clutter both displays and hides . . . I'm working on a book about it. We'll see.

QUEENS, NEW YORK, UNITED STATES OF AMERICA

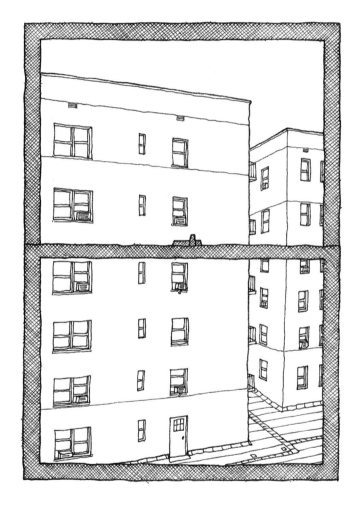

2013

Teju Cole

I live on the second floor of a hundred-year-old row house in Brooklyn. But this is not the Brooklyn people think about when they think about writers living in Brooklyn. There are no cafés on my street, no bookshops in my neighborhood, and though there are shops that sell clothes, they are not the fashionable boutiques of Fort Greene or Williamsburg. My neighborhood is called Sunset Park. It lies between the Green-Wood Cemetery and the Verrazano-Narrows Bridge. The neighborhood is populated mostly by people from Puerto Rico, Mexico, China, and Southeast Asia. Most are recent immigrants.

I write at home in a room that doubles as the dining room, on a large modern table of vaguely Danish design. The exposure is southwest, and in winter the room can be as bright as a countryside. The sun pours in from early morning till late in the afternoon. It is my favorite room in the apartment. During the day, I often go up to the windows and look out past the fire escape onto the row of houses across from mine. What I see is not the fronts of these houses but their backs; their backs face the backs of the houses in the row on which I live. This arrangement makes me think of canal-side houses, as though the space between the houses were now no longer ordinary New York City backyards, as though we were now in Amsterdam and we were facing each other, and there was water below. And each day when the sun goes down and my room darkens and my neighbors' lights begin to twinkle on one by one, I leave the page and begin to imagine their lives and their imaginations, in all those foreign languages, and the shortage of bridges between them and me.

BROOKLYN, NEW YORK, UNITED STATES OF AMERICA

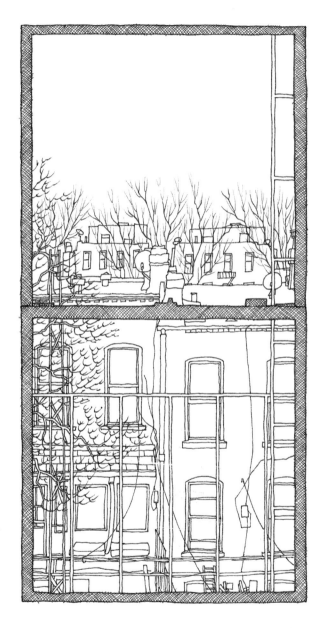

2014

Lysley Tenorio

From room 1006 at the Standard, East Village, you see a white-faced clock overlooking a small triangular park. To the right is a sea-green dome ringed with small arched windows, partly blocked by a boxy rectangular building, faded and plain except for the cross on its south-facing wall, and on the rooftop hangs a single line of laundry. Straight ahead is a building, wide and blank as a wall, that nobody seems to enter or exit.

If you don't live in New York, you might not know the names or histories of these buildings, how they function in the city, what they mean to its people. But this is the gift of being somewhere new, in a place that will never be home—everything within is defined by your first impressions. For instance: That sea-green dome, so out of place and time, might house things both ancient and futuristic— rusted astrolabes on the shelves, side by side with next-generation iPads. The crucifix could be the final remnant of a failed church, the original cathedral demolished decades ago, replaced by a building full of a thousand cubicles. That white-faced clock, the brightest thing at night, may very well be the front of a crimefighter's head-quarters or a supervillain's lair. That line of laundry, winter-damp and flapping—those are the clothes of a dead man who left no loved ones behind to gather them. And directly across, that building is lifeless as ever, but someone is inside, waiting to be glimpsed, you're sure of it. All you need to do is wait.

New York City, New York, United States of America

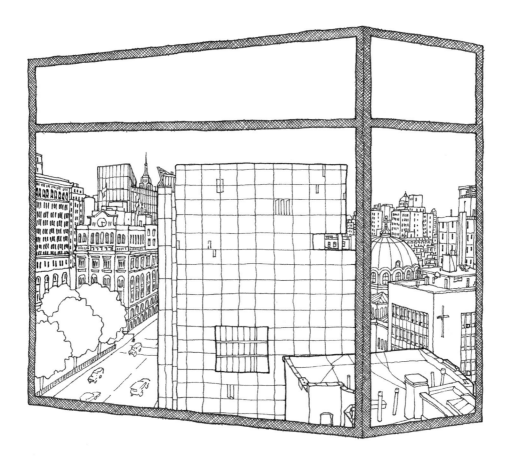

2013

John Jeremiah Sullivan

This is the back view from my office. It's raining. You can see a wall of the old garage (which still has a deep oil pit inside, from when more people worked on their own cars). The magnolia that hangs over the backyard is blooming. When it does, we open the door to the sleeping porch upstairs, and the whole house fills with the smell. My wife will cut one of the flowers and let it float in a bowl of water on the kitchen table. Magnolias drop hundreds of large seedpods once a year—they come crashing down from the tree. I'm always worried one of them is going to land on somebody's head (they're heavy enough to hurt). We spend about a month just picking them up. They look like brown-green grenades but are bursting all over with bright red seeds. The leaves, when they turn brown and fall, are hard and brittle. That's a problem down here, because tiny pools of water form on them, and the mosquitoes lay eggs there. You have to pick them up fast. In short, a big magnolia is a lot of work, but I would never get rid of this one. The week or so of blossoming is worth everything. Also, the branches cover the whole brick path from the back door to the driveway. Even in a heavy storm, you can just walk along dry. Sometimes I pat the tree's trunk and thank it for that, or just to say hello. Once, when we first got home from a trip of two months, my daughter—who was four at the time—hugged the tree long and fiercely, saying nothing, before she ran inside. I think it's sort of the guardian of the house.

WILMINGTON, NORTH CAROLINA, UNITED STATES OF AMERICA

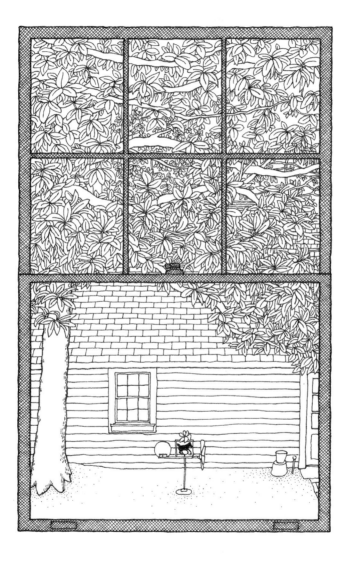

2012

Edwidge Danticat

I can't see outside my office window unless I'm standing up. My desk sits beneath the window ledge, like a footstool for some escaping giant. This seems fitting because I live on the edge of two very different neighborhoods: one a trendy design hub and the other a gentrifying working-class enclave. The fact that when I look up from my desk I see only curtains and glass is both comforting and distancing. And when I do stand up and look out, I see hedges surrounded by a little gate, something that looks like another kind of window, a floor-to-ceiling one, except there is no actual ceiling.

I work at home, which means there is no ceiling on my home or work life either. They run into each other the way nights run into days when the work is going really well. I purposely choose to work on the side of the house with the simplest view. The plain scenery reminds me of a theater curtain in a minimalist high school play. The trees, electric wires, and even the church steeple in the distance all look like they've been drawn by the same giant who would use my desk as a footstool, perhaps to wave to the people talking loudly as they walk by. For every person the hedge blocks from my view, I hear four voices, sometimes whispering, sometimes arguing, and sometimes even singing late into the night. And rather than disturb me this makes me feel like I am on a journey with kin and strangers alike. As my loved ones walk, or sleep, on one side of the wall, others roam the world, the way the characters in my stories roam beyond my window, and even beyond my imagination. Finally, when I open that little metal gate and step outside, the world feels both foreign and familiar. Like I have been gone, but not too long.

MIAMI, FLORIDA, UNITED STATES OF AMERICA

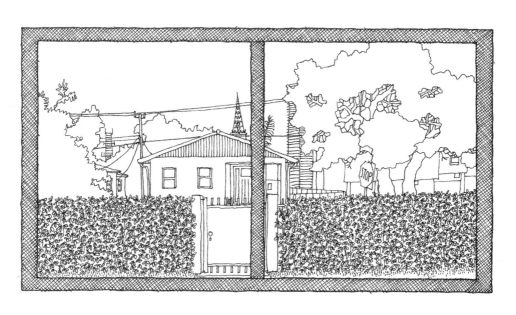

2013

T. C. Boyle

I've never felt the need to slip off to a writers' colony in order to get a dose of nature and tranquility, my satire of such places in *East Is East* notwithstanding. What I'm looking at in this view out the window from my desk is a big oak tree just beyond the roofline, and beyond that—oh, maybe three miles off—the high buff ridge of the Santa Ynez Mountains. In between is a whole lot of vegetation, a big scoop of sky, and the hawks that hang there like mobiles. The mullion that frames the view is unique to this house, Frank Lloyd Wright's first California design, and its T-shape is meant to depict a tree. This is because the house is surrounded by forest, a forest that once welcomed overwintering monarchs in great numbers (which are now, alas, greatly reduced), and so was known as "Butterfly Woods" at its inception more than a century ago.

What do I get out of all this? Distraction and lack of distraction both. I can pause, look up from my work, and see the way the light sits in the trees or observe the woodpeckers and squirrels raiding acorns from the oak, and yet there are no larger distractions in the form of traffic, noise, and big-ape bustle. When I'm done with work I go out into those woods and maintain things in a proprietary way, gathering firewood, applying precious water where necessary, meditating over the fish in the pond in back. It's all very semi-rural, semi-natural and fully relaxing. Unlike the architect who designed the house and seemed to require chaos in his life in order to create, I need peace and tranquility. I look out my window here and that's just what I've got. What can I say but Hallelujah!

MONTECITO, CALIFORNIA, UNITED STATES OF AMERICA

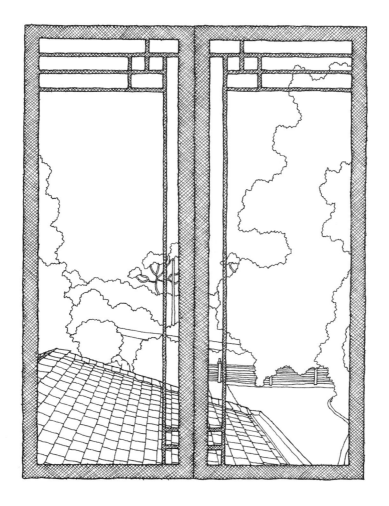

2014

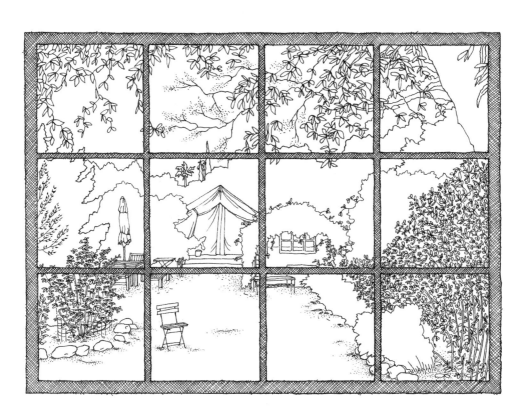

2014

Michelle Huneven

My office is a small hut in the backyard about fifty feet from the house, which is on a large flag lot deep inside a suburban block. It's very private, I see only our neighbor's trees—there's not a power line, a street, or even a roof in sight; it's like working in a park or another century.

Formerly, this land was part of the West India Gardens, a nursery owned by Frederick Popenoe, the man who brought dates and the fuerte avocado to Southern California. The gardens were mostly gone by the time I moved in, but from my desk, I see the three ancient, enormous eucalyptus trees that preside over the yard. We call them the King, the Queen, and the Prince. We worship them, and keep them trimmed (so they won't blow down in the Santa Ana winds and flatten the house), and rake up the fantastical quantities of acorns, sticks, leaves, and bark they perenially shed.

I live a mile east of where I grew up, and where my father grew up before me (a succession rare in California). When he was eight, my father ran away from home with a friend and the two spent the night on this very property tussling over one thin blanket beneath the royal family—which is how Dad recognized the place eighty years later when he came to see my new home.

I have replanted with citrus, olives, cacti, roses, and vegetables, and hedged the yard into a series of outdoor rooms. Between the King and the Queen, we trained a vine over an old metal gazebo to create a shade house; our electrician dubbed it "the creepy clubhouse," and the name stuck. Then, across the yard from my desk, partly obscured by a pomegranate hedge, we've installed a large outfitters tent as a spare bedroom; it reminds some people of sa-

fari, some of high mountain camps, some of Lincoln visiting his generals during the Civil War.

I like to think a runaway boy would find much to his liking here today.

For years now this has been what I see when I work; not surprising, it's what I visualize whenever I so much as think of getting down to it. This setting has become the base camp, the portal of my imagination; from here, day after day, I begin.

ALTADENA, CALIFORNIA, UNITED STATES OF AMERICA

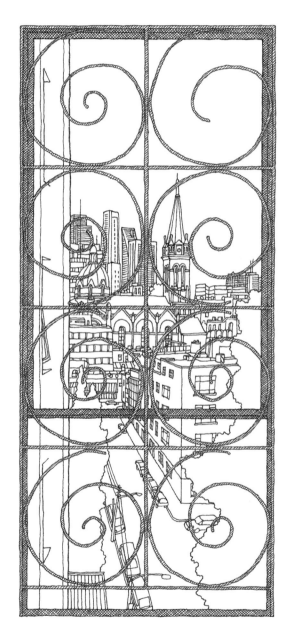

2012

Francisco Goldman

My desk is snugly ensconced in a front corner of the living room, facing wall and bookshelves, a wide window overlooking a park in Colonia Roma to the right and, on my left, the narrow side window drawn by Matteo. I'm sharing the apartment with my friend Jon Lee, who is almost always traveling, but he needed a Latin American base for his work. We only moved in a month ago. It's the biggest apartment I've ever lived in. The living room is so immense that I bought a football (not a *futbol*) just to prove you can play catch in it, and now I am looking for a Wiffle ball batting machine, which I think would be a great way to manage the persistent physical restlessness that often makes it so hard for me to sit still at a desk. In the mornings I go down to a café facing the park for breakfast. They have terrific coffee. I usually have the waitress tell me about the *chilaquiles,* the *enfrijoladas, molletes,* and *omelettes* just so that I can savor her descriptions, and then I order the fruit and granola, and she makes fun of me for that. I work in the café for two or three hours and then go back to the desk in my apartment. Apart from a break for lunch, I try to work until seven in the evening, and then usually head to the gym. We're right around the corner from one of Mexico City's greatest cantinas, one I'd been coming to for years from more distant neighborhoods. They have a funny ritual there. A waiter will ring a bell to catch everyone's attention, shout out a name, and then the cavernous room will resound with raucous shouts of *"¡Pendejo!"* (it means, more or less, "Asshole!"). You have to pay the waiter to do that. Once a good friend, a writer from Ireland, was visiting, and he paid the waiter to shout out the name of another Irish writer who'd given him a nasty review, and the waiter,

though he could barely pronounce the name, shouted it out, and everyone in the cantina, the old men playing dominoes, the Mexican and foreign hipsters, and literary types who also hang out there, et cetera, joyously shouted, *"¡Pendejo!"*

<div align="right">MEXICO CITY, MEXICO</div>

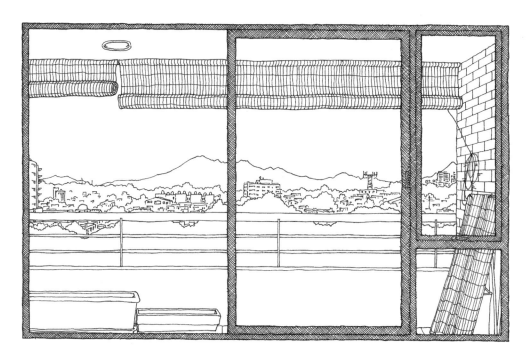

2013

Rodrigo Rey Rosa

What seems from here a pleasant view could one of these days become a show of pyrotechnics. At present the volcanoes, active or not, are covered by haze. In the afternoon the wind that rises from the nearby sea, hidden by the mountain range and the volcanoes, will disperse the mist and reveal: the Pacaya (the most active, and the closest), the Agua, the Fuego (capable of spraying ash all the way to Tapachula, Mexico), the Acatenango, and, almost invisible to the west, the Tolimán and the Atitlán. Another thing that cannot be seen from here: Beyond the tall buildings that have sprung up over the last ten years in the southern part of the city lies a deep ravine that hides a *limonada*—the local name for the slums that house the garbage dumps. There ends the city.

Sometimes the noises of the *limonada* reach me here: an evangelical hymn, a party (woofers, norteñas, reggaetón), firecrackers, bombs, occasionally a shootout.

Buildings aside, the view behind me as I write—the sky, the changing clouds, the volcanoes—is practically the same one I could see as a child from the roof of my parents' house, which sits behind the bamboo bushes down there, in the foreground—and beyond that, the unseen too remains unchanged: the ravine and the *limonada,* now denser by way of gentrification, more populous due to the waves of peasants displaced either by the civil war that ended not too long ago or by chronic poverty, turned into proletarians or gang members, often out of control.

Very little history—the remains of a colonial aqueduct built on a pre-Columbian mound that passes through here, under the balcony, spanning half the city from east to west—and plenty of me-

teorology can be viewed from this south-facing window, in a multistory condo with surveillance cameras, security gates, and armed guards, just in case.

What an illustrious traveler wrote more than half a century ago—"The provincial capital was saved from ugliness only by its trees"—still seems accurate, at least from this window.

These sorts of things often come to mind here, as I write.

(Translated from the Spanish by Jessica Henderson.)

GUATEMALA CITY, GUATEMALA

Alejandro Zambra

I'm not sure that my little studio is the best place in the house to write. It's too hot in summer and too cold in winter. But I like this window. I like those trees crossed by power lines and that slice of available sky. The silence is never absolute, or maybe it is—maybe my idea of silence now includes the constant barking of dogs and the uneven roar of motors. I take enormous pleasure in watching passersby, the odd cyclist, the cars.

When the writing isn't happening I just sit there, absorbing the scenery, adoring it. I'm sure those minutes, those apparently lost hours, are useful in some way, that they're essential for writing: that my books would be very different if I had written them in another room, looking out another window.

(Translated from the Spanish by Harry Backlund.)

SANTIAGO, CHILE

2013

Tatiana Salem Levy

Although I have an office in my apartment, every day I wake up and take my laptop to the dining room table. The view from my dining room has an amplitude that takes me away, and when I write I need the feeling that space and time have no end. I can't stand writing in enclosed places, nor having just an hour to work.

When I sit at the table, the morning is still quiet; I hear one or another child leaving for school and the birds that often come to visit me at the window. That's when I write best, inspired by the imbalance and the irregularity of the buildings in front of me. Then, throughout the day, inspiration will fail. I get up and lean on the window to see what I can't see while seated: a huge mountain to the right with a statue of Christ on top. In silence, I start talking to the man with open arms until my thoughts get lost and I decide to go back to the chair. And so my days elapse, between the table and the window.

RIO DE JANEIRO, BRAZIL

2013

Daniel Galera

The large window facing the small square, showing the short residential buildings and the treetops, is one of the main reasons I moved to this apartment. Some kind of open view really helps my mood in order to work, but there's a special kind I prefer. A wide and beautiful natural landscape is distracting to me: I feel like going outside and must close the window. A window facing a wall is worse, I feel oppressed. This is just what I need: a square with some trees, people, and noise. Even the traffic noise is somewhat stimulating to me—that way I am connected with my urban environment, with city life, I am aware of people living and doing other stuff around me, and that breaks the continual isolation often required to write, softening the solitude. While facing the mostly unchanging picture at my window, I listen to dogs and birds, a girl practicing the flute, the roar of buses and trucks, ambulance sirens, wind and rain, the rants of the crazy and the homeless, the loud music and fistfights of late hours, and sometimes even silence, prolonged silence. Some windows are an escape for daydreaming, but this one kind of keeps me company.

PORTO ALEGRE, BRAZIL

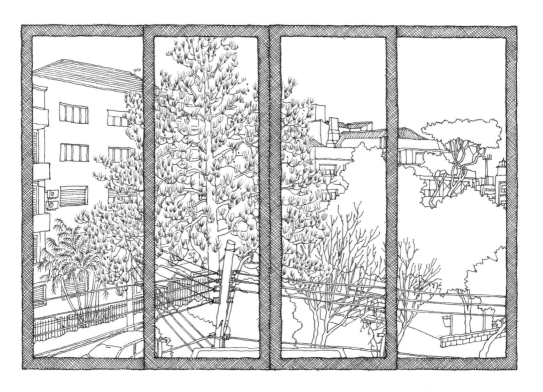

2014

Maria Kodama

A certain house in the Buenos Aires neighborhood of Recoleta has a window that is doubly privileged. It overlooks a courtyard garden of the kind known here as a *pulmón de manzana*—literally, the lung of a block—which affords it a view of the sky and an expanse of plants, trees, and vines that meander along the walls of neighboring houses, marking the passage of the seasons with their colors. In addition, the window shelters the library of my late husband, Jorge Luis Borges. It is a real Library of Babel, full of old books, their endpapers scribbled with notes in his tiny hand.

As afternoon progresses and I look up from my work to gaze out this window, I may be invaded by springtime, or if it's summer, by the perfume of jasmine or the scent of orange blossom, mingled with the aroma of leather and book paper, which brought Borges such pleasure.

The window has one more surprise. From it, I can see the garden of the house where Borges once lived, and where he wrote one of his best-known short stories, "The Circular Ruins." Here, I can move back and forth between two worlds. Sometimes, following Borges, I wonder which one is real: the world I see from the window, bathed in afternoon splendor or sunset's soft glow, with the house that once belonged to Borges in the distance, or the world of the Library of Babel, with its shelves full of books once touched by his hands?

(Translated from the Spanish by Esther Allen.)

BUENOS AIRES, ARGENTINA

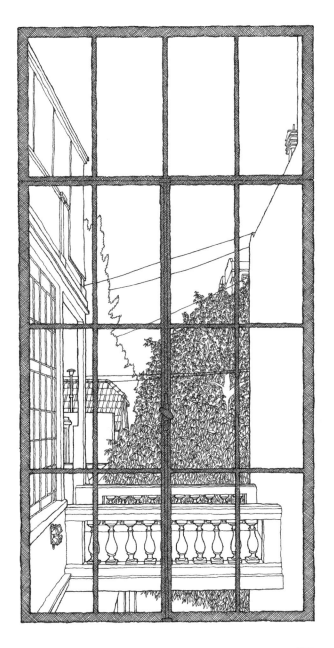

2010

Contributors

LEILA ABOULELA grew up in Sudan and moved to Scotland in her mid-twenties. She is the author of *Lyrics Alley, Minaret*, and *The Translator.*

CHIMAMANDA NGOZI ADICHIE was born in Nigeria. She is the author of *Purple Hibiscus, Half of A Yellow Sun, The Thing Around Your Neck,* and *Americanah*, which won the 2013 National Book Critics Circle Award and the Heartland Prize.

ALAA AL ASWANY was born in 1957. A dentist by profession, Al Aswany is the author of the bestselling novel *The Yacoubian Building, Chicago*, and a novella and short story collection, *Friendly Fire*. He lives in Cairo.

CHRISTINE ANGOT is a French novelist, short story writer, and playwright.

ROTIMI BABATUNDE is the author of *Bombay's Republic*, for which he was awarded the 2012 Caine Prize for African Writing. He lives in Ibadan, Nigeria.

T.C. BOYLE is the author of twenty-five books of fiction, including, most recently, volume II of his *Collected Stories* (2013), and the novel, *San Miguel* (2012). He lives in Santa Barbara, California.

GERALDINE BROOKS has authored four novels and two works of nonfiction. Her 2006 novel, *March*, won the Pulitzer Prize for Fiction. Born and raised in Sydney, she was a foreign correspondent for the *Wall Street Journal* in the Middle East, Africa and the Balkans before turning to fiction. She lives on Martha's Vineyard.

XI CHUAN (pen name of Liu Jun) is a Chinese poet, essayist, and translator. Born in 1963 in Jiangsu province, he graduated from Beijing University in 1985. He is currently professor of Chinese literature at Beijing's Central Academy of Fine Arts. Xi Chuan has published six collections of poems, including *Personal Preferences* and *A Dream's Worth*, two books of essays, two books of criticism, and numerous translations. His book of poems in English, *Notes on the Mosquito* (tr. Lucas Klein), was published by New Directions in 2012.

TEJU COLE was born in the United States in 1975 and raised in Nigeria. He is the author of *Every Day is for the Thief* and *Open City*, which won the PEN/

Hemingway Award, the New York City Book Award for Fiction, the Rosenthal Award of the American Academy of Arts and Letters, and the Internationaler Literaturpreis, and was shortlisted for the National Book Critics Circle Award, the New York Public Library Young Lions Award, and the Ondaatje Prize of the Royal Society of Literature. He lives in Brooklyn.

EDWIDGE DANTICAT was born in Haiti in 1969, and was raised by her aunt under the dictatorial Duvalier regime (her parents left for the U.S. when she was four). Her work has appeared in *The New Yorker* and many anthologies. She is the author of several books of nonfiction, most notably *Brother, I'm Dying* (Knopf, 2007), which was nominated for a National Book Award. She was the recipient of a MacArthur Foundation "Genius" Grant in 2009. Her most recent novel, *Claire of the Sea Light*, was published by Knopf in 2013.

RANA DASGUPTA was born in the U.K., and studied at the universities of Oxford and Wisconsin. He is the author of the highly praised linked short story collection, *Tokyo Cancelled*, which was shortlisted for the 2005 John Llewellyn Rhys Prize (U.K.) and the Hutch Crossword Book Award (India), and the novel *Solo*, which won the Commonwealth Writers' Prize 2010 for Best Book. He lives in Delhi, India.

NASTYA DENISOVA was born in St. Petersburg in 1984. She is the author of two books of poems, *There is Nothing* (2006), and *On* (2010).

LIDIJA DIMKOVSKA was born in Skopje, Macedonia, in 1971. She is a poet, novelist and translator, winner of the 2013 European Union Prize for Literature. She lives in Slovenia.

CERIDWEN DOVEY grew up in Australia and South Africa. She is the author of the novel *Blood Kin* and a collection of short stories, *Only the Animals*. She was selected as one of the National Book Foundation's "5 under 35" and named by the *Wall Street Journal* as "an artist to watch." She lives in Sydney, Australia.

MARINA ENDICOTT was born in Golden, British Columbia, and worked as an actor and director in Canada and the U.K. before she began to write fiction. She was a finalist for the 2008 Giller Prize, the 2011 Governor General's Award, and won the 2009 Commonwealth Writers Prize for Best Book, Canada/Caribbean region. She lives in Alberta, Canada.

NURUDDIN FARAH was born in 1945 in Baidoa, in what is now Somalia, and grew up in Kallafo, under Ethiopian rule in the Ogaden. He is at work on a new trilogy, the overall title of which is *The Collapse*. The first book, *Links*, was published by Riverhead in 2004, and the second, *Knots*, was published by Riverhead in 2007. The final title in the trilogy, *Crossbones*, was published by Riverhead in 2011 and was a finalist for the Hurston/Wright Legacy Award 2012. His next novel, *Hiding in Plain Sight*, was published by Riverhead in 2014.

RICHARD FLANAGAN is the author of five previous novels—*Death of a River Guide, The Sound of One Hand Clapping, Gould's Book of Fish, The Unknown Terrorist,* and *Wanting*—which have received numerous honors and have been published in twenty-six countries. He lives in Tasmania.

DANIEL GALERA is a Brazilian writer and translator. His latest novel, *Blood-Drenched Beard,* is forthcoming in January 2015 from Penguin Press.

FRANCISCO GOLDMAN is the author, most recently, of *Say Her Name*, winner of the 2011 Prix Femina Étranger, and of *The Interior Circuit: A Mexico City Chronicle*.

NADINE GORDIMER was a South African writer, political activist and recipient of the 1991 Nobel Prize in Literature. She was very active in anti-apartheid causes (several of her works were banned by the South African government) and the themes of moral and racial issues are reflected prominently in her work. Aside from the Nobel Prize, she received the 1974 Booker Prize and France's Legion of Honour among many other awards, and was named an honorary member of the American Academy of Arts and Sciences, a fellow of Britain's Royal Society of Literature, a patron of the Congress of South African Writers, and a Commandeur de l'Ordre des Arts et des Lettres.

JOUMANA HADDAD is an award-winning Lebanese writer and journalist, and a prominent women's rights activist. She was selected as one of the world's 100 most powerful Arab women in March 2014 for her cultural and social activism. Her most recent publications are "I Killed Scheherazade, confessions of an angry Arab woman," and "Superman is an Arab," both available on Amazon.

SHEILA HETI is the author of six books, including the novel, *How Should a Person Be?,* which was included on many Best of the Year lists, including in the *New York*

Times and *Salon.* Her work has been published in *The London Review of Books*, *McSweeney's, n+1, Harper's,* and *The Believer.* She lives in Toronto.

ANDREA HIRATA is an Indonesian author. His first novel, *The Rainbow Troops,* is the winner of New York Book Festival 2013 in the general fiction category and has been translated into more than twenty languages.

MICHELLE HUNEVEN is the author of four novels, most recently *Blame* and *Off Course.* She lives in Altadena, California, and teaches creative writing at UCLA.

DANIEL KEHLMANN was born in Munich in 1975 and lives in Berlin and New York. His works have won the Candide Prize, the Kleist Prize, the Welt Literature Prize, and the Thomas Mann Prize.

ETGAR KERET's forthcoming book *The Seven Good Years* will be published by Riverhead in 2015.

HARRIS KHALIQUE is a poet, essayist and columnist based in Islamabad, Pakistan. His major works in Urdu and English poetry include *Ishq Ki Taqveem Mein* (2006), *Between You and Your Love* (2012), and the award-winning collection *Melay Mein* (2012).

KARL OVE KNAUSGAARD was born in Norway in 1968. *My Struggle* has won countless international literary awards and has been translated into over fifteen languages. Knausgaard lives in Sweden with his wife and three children.

MARÍA KODAMA was born in Buenos Aires and began studying and translating Anglo-Saxon and Icelandic with Jorge Luis Borges at the age of sixteen. She has lectured widely throughout Europe, Asia, and the Americas and is the founder and president of the Fundación Internacional Jorge Luis Borges and the Museo Borges. She has been named an Officier de l'Ordre des Arts et des Lettres by the French Government and a winner of the Premio Jorge Luis Borges by the Argentinean government.

LAURI KUBUITSILE is an award-wining writer living in Botswana. She is the author of numerous books for both children and adults, and has twice won Africa's

premier prize for children's writing, *The Golden Baobab*, and was shortlisted for the Caine Prize in 2011.

EMMA LARKIN is the pseudonym for an American journalist who was born and raised in Asia, studied the Burmese language at the School of Oriental and African Studies in London, and covers Asia widely in her journalism from her base in Bangkok. She has been visiting Burma for close to ten years.

ELMORE LEONARD wrote forty-five novels and nearly as many western and crime short stories across his long and successful career, many of which have been made into popular films and TV shows, including *Out of Sight, Get Shorty, Jacky Brown, 3:10 to Yuma* and the FX hit series, *Raylan.* He received the National Book Foundation's Medal for Distinguished Contribution to American Letters, PEN USA's Lifetime Achievement Award, and the Mystery Writers of America's Grand Master Award. He was known to many as the Dickens of Detroit and lived there from 1934 until his death in 2013.

ANDREA LEVY is the author of the multi-award winning novel *Small Island* and the Booker shortlisted *The Love Song.* She lives and works in London.

TATIANA SALEM LEVY is a Brazilian author, born in 1979. Her first novel, *The House in Smyrna*, will be published in the U.K. in 2015 by Scribe.

LULJETA LLESHANAKU is the author of three collections of poems published in English, and several others in Albanian and other languages.

ANDRI SNÆR MAGNASON was born in 1973. His work has been published or performed in more than thirty languages. Andri has received the Philip K. Dick Award for *LoveStar*, the UKLA Award for *The Story of the Blue Planet* and all the categories of the Icelandic Literary Award. He lives in Reykjavík with his wife and four children.

MIKE McCORMACK comes from the west of Ireland and is the author of two novels, *Crowe's Requiem* and *Notes from a Coma*, and two collections of short stories, *Getting it in the Head* and most recently *Forensic Songs.* His work has been translated into several languages.

JON McGREGOR is the author of *If Nobody Speaks of Remarkable Things, So Many Ways to Begin, Even the Dogs,* and *This Isn't the Sort of Thing That Happens to Someone Like You.* He has won the Betty Trask Prize and the Somerset Maugham Award, has twice been longlisted for the Man Booker Prize, and was the runner-up for the 2010 and 2011 BBC National Short Story Awards.

G. MEND-OOYO is a Mongolian poet, writer and calligrapher. He was born into a herder's family in Dariganga, Mongolia. Mend-Ooyo lives in Ulaanbaatar, Mongolia, and directs the Mongolian Academy of Culture and Poetry.

RYU MURAKAMI is the *enfant terrible* of contemporary Japanese Literature, and the author of dozens of books, including the prize-winning *In the Miso Soup, Almost Transparent Blue,* and *Audition.*

ORHAN PAMUK is the author of eight novels, a memoir, and three works of nonfiction. His work has been translated into over fifty languages. In 2006, he was the winner of the Nobel Prize in Literature and in 2012 he inaugurated the Museum of Innocence, in Istanbul, where he was born and continues to live.

TIM PARKS is the author of fifteen novels, including *Europa,* which was shortlisted for the Booker Prize; four acclaimed memoirs of life in contemporary Italy; and other nonfiction works. He runs a postgraduate degree program in translation at IULM University in Milan and has translated works by Moravia, Calvino, Calasso, Machiavelli and others.

RODRIGO REY ROSA was born in Guatemala in 1958 and has lived in New York City and Tangier. He has translated several books by Paul Bowles into Spanish, and authored many novels and story collections, including *El cuchillo del mendigo (The Beggar's Knife), Cárcel de árboles (The Pelicari Project), El cojo bueno (The Good Cripple), La orilla africana (The African Shore), Severina,* and most recently, *Los sordos (The Deaf).*

TAIYE SELASI was born in London and raised in Massachusetts. She holds a B.A. in American studies from Yale and an M.Phil. in international relations from Oxford. "The Sex Lives of African Girls" (Granta, 2011), Selasi's fiction debut, appeared in *Best American Short Stories 2012* and her debut novel, *Ghana Must Go,* was published in 2013.

premier prize for children's writing, *The Golden Baobab*, and was shortlisted for the Caine Prize in 2011.

EMMA LARKIN is the pseudonym for an American journalist who was born and raised in Asia, studied the Burmese language at the School of Oriental and African Studies in London, and covers Asia widely in her journalism from her base in Bangkok. She has been visiting Burma for close to ten years.

ELMORE LEONARD wrote forty-five novels and nearly as many western and crime short stories across his long and successful career, many of which have been made into popular films and TV shows, including *Out of Sight, Get Shorty, Jacky Brown, 3:10 to Yuma* and the FX hit series, *Raylan*. He received the National Book Foundation's Medal for Distinguished Contribution to American Letters, PEN USA's Lifetime Achievement Award, and the Mystery Writers of America's Grand Master Award. He was known to many as the Dickens of Detroit and lived there from 1934 until his death in 2013.

ANDREA LEVY is the author of the multi-award winning novel *Small Island* and the Booker shortlisted *The Love Song*. She lives and works in London.

TATIANA SALEM LEVY is a Brazilian author, born in 1979. Her first novel, *The House in Smyrna*, will be published in the U.K. in 2015 by Scribe.

LULJETA LLESHANAKU is the author of three collections of poems published in English, and several others in Albanian and other languages.

ANDRI SNÆR MAGNASON was born in 1973. His work has been published or performed in more than thirty languages. Andri has received the Philip K. Dick Award for *LoveStar*, the UKLA Award for *The Story of the Blue Planet* and all the categories of the Icelandic Literary Award. He lives in Reykjavík with his wife and four children.

MIKE McCORMACK comes from the west of Ireland and is the author of two novels, *Crowe's Requiem* and *Notes from a Coma*, and two collections of short stories, *Getting it in the Head* and most recently *Forensic Songs*. His work has been translated into several languages.

JON McGREGOR is the author of *If Nobody Speaks of Remarkable Things, So Many Ways to Begin, Even the Dogs,* and *This Isn't the Sort of Thing That Happens to Someone Like You.* He has won the Betty Trask Prize and the Somerset Maugham Award, has twice been longlisted for the Man Booker Prize, and was the runner-up for the 2010 and 2011 BBC National Short Story Awards.

G. MEND-OOYO is a Mongolian poet, writer and calligrapher. He was born into a herder's family in Dariganga, Mongolia. Mend-Ooyo lives in Ulaanbaatar, Mongolia, and directs the Mongolian Academy of Culture and Poetry.

RYU MURAKAMI is the *enfant terrible* of contemporary Japanese Literature, and the author of dozens of books, including the prize-winning *In the Miso Soup, Almost Transparent Blue,* and *Audition.*

ORHAN PAMUK is the author of eight novels, a memoir, and three works of nonfiction. His work has been translated into over fifty languages. In 2006, he was the winner of the Nobel Prize in Literature and in 2012 he inaugurated the Museum of Innocence, in Istanbul, where he was born and continues to live.

TIM PARKS is the author of fifteen novels, including *Europa,* which was shortlisted for the Booker Prize; four acclaimed memoirs of life in contemporary Italy; and other nonfiction works. He runs a postgraduate degree program in translation at IULM University in Milan and has translated works by Moravia, Calvino, Calasso, Machiavelli and others.

RODRIGO REY ROSA was born in Guatemala in 1958 and has lived in New York City and Tangier. He has translated several books by Paul Bowles into Spanish, and authored many novels and story collections, including *El cuchillo del mendigo (The Beggar's Knife), Cárcel de árboles (The Pelicari Project), El cojo bueno (The Good Cripple), La orilla africana (The African Shore), Severina,* and most recently, *Los sordos (The Deaf).*

TAIYE SELASI was born in London and raised in Massachusetts. She holds a B.A. in American studies from Yale and an M.Phil. in international relations from Oxford. "The Sex Lives of African Girls" (Granta, 2011), Selasi's fiction debut, appeared in *Best American Short Stories 2012* and her debut novel, *Ghana Must Go,* was published in 2013.

JOHN JEREMIAH SULLIVAN is a contributing writer for *The New York Times Magazine* and the Southern editor of the *Paris Review*. His most recent book, *Pulphead,* was a National Book Critics Circle Award nominee. He lives in Wilmington, North Carolina.

LYSLEY TENORIO is the author of *Monstress* (Ecco/HarperCollins), and teaches at Saint Mary's College of California. In 2014, he was the Inaugural *Paris Review* Writer-in-Residence at the Standard Hotel in New York City.

BINYAVANGA WAINAINA was born in Nakuru, Kenya. He is the founder of the magazine, *Kwani?* and author of the memoir, *One Day I Will Write About This Place*, a *New York Times* Notable Book of 2011. *Time* Magazine named him one of the 100 "Most Influential People in the World" in 2014.

REBECCA WALKER is an award-winning writer and lecturer, named by *Time* magazine as one of the most influential leaders of her generation. She is the author of the memoirs *Black, White, and Jewish* and *Baby Love*, and the editor of the anthologies *To Be Real*, *What Makes a Man*, *One Big Happy Family*, and *Black Cool*. Her most recent novel is *Adé: A Love Story.*

BARRY YOURGRAU's books of stories include *Wearing Dad's Head*, *Haunted Traveler*, and *The Sadness of Sex*, which was also made into a film in which the author starred. His memoir, *Mess*, is forthcoming. He lives in New York and part-time in Istanbul.

ALEJANDRO ZAMBRA was born in Santiago de Chile in 1975. He is the author of *Bonsai*, *The Private Lives Of Trees*, *Ways Of Going Home*, and *My Documents*. Some of his short stories have been published in *The New Yorker, The Paris Review, Zoetrope* and *Mcsweeney's*.

Acknowledgments

I would like to thank all the people whose views I have drawn. It has truly been an honor and a joy to be able to see and absorb all these wonderful places even without ever having left my studio. When I close my eyes, I can still see all of your views. I would also like to thank all the people who have helped me gather the photographic material, who have put me in contact with the writers, and who have supported this project. I unfortunately cannot list all of you here, as you have been so many. Thanks to Clay Risen and Aviva Michaelov of the *New York Times,* who were great supporters of the series. I am especially grateful to David Shipley, who initially envisioned the series in a broader and more inspiring way than I could have ever imagined, and to Scott Moyers, who championed the idea from the very beginning all the way through to its becoming a book. At Penguin Press, I'd like to thank, among others, Mally Anderson and Claire Vaccaro. A very special thanks to Lorin Stein, Clare Fentress, and the *Paris Review* staff for the care and attention they have dedicated to the series. A heartfelt thanks to Luke Ingram and everyone at the Wylie Agency, who so patiently and consistently helped with this incredibly time-consuming and energy-absorbing cumulative effort every step of the way, and especially Rebecca Nagel, whom I cannot thank enough for her dedication, support, and guidance throughout the entire project.

WITHDRAWN
BY
WILLIAMSBURG REGIONAL LIBRARY

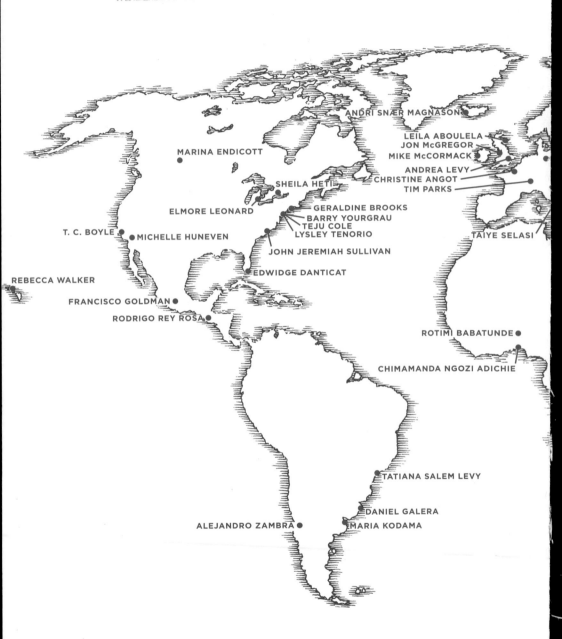

ANDRI SNÆR MAGNASON

LEILA ABOULELA
JON McGREGOR
MIKE McCORMACK

MARINA ENDICOTT

ANDREA LEVY
CHRISTINE ANGOT
TIM PARKS

SHEILA HETI

GERALDINE BROOKS
BARRY YOURGRAU
TEJU COLE
LYSLEY TENORIO

ELMORE LEONARD

T. C. BOYLE
MICHELLE HUNEVEN

TAIYE SELASI

JOHN JEREMIAH SULLIVAN

EDWIDGE DANTICAT

REBECCA WALKER

FRANCISCO GOLDMAN

RODRIGO REY ROSA

ROTIMI BABATUNDE

CHIMAMANDA NGOZI ADICHIE

TATIANA SALEM LEVY

DANIEL GALERA

ALEJANDRO ZAMBRA
MARIA KODAMA